IMAGES
of America

CECIL COUNTY

D1193662

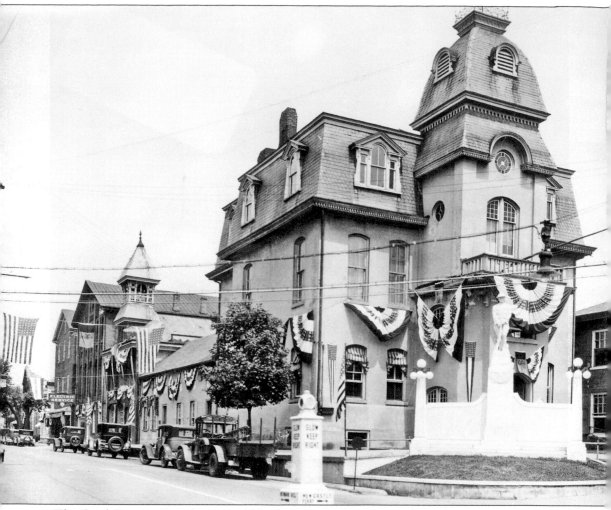

The Cecil County Courthouse and North Street buildings were dressed in stars and stripes in 1932 to celebrate the bicentennial of George Washington's birthday. Washington knew Cecil County well. He did not just sleep here; he wined and dined with friends, conducted business, watched the British prepare for the march on Philadelphia, sent wounded soldiers to a Quaker meetinghouse here, fed his army with food shipped from here, and loaded heavy ordnance on boats at Elk Landing before marching on to Yorktown. (Courtesy of the Historical Society of Cecil County.)

ON THE COVER: The "Gold Mine Bridge" at Perryville was originally an obsolete railroad bridge over the Susquehanna given away to a consortium of politicians from both sides of the river, who collected tolls for 13 years and then sold it to the state for $585,000 in 1923. The bridge became inadequate for two-way traffic, so in 1927, the state added a second deck, noticeable in this photograph. The state removed the toll the following year and tore the bridge down in 1943. (Courtesy of the Historical Society of Cecil County.)

IMAGES
of America

CECIL COUNTY

Milt Diggins

ARCADIA
PUBLISHING

Copyright © 2008 by Milt Diggins
ISBN 978-0-7385-5366-5

Published by Arcadia Publishing
Charleston, South Carolina

Printed in the United States of America

Library of Congress Catalog Card Number: 2007939175

For all general information contact Arcadia Publishing at:
Telephone 843-853-2070
Fax 843-853-0044
E-mail sales@arcadiapublishing.com
For customer service and orders:
Toll-Free 1-888-313-2665

Visit us on the Internet at www.arcadiapublishing.com

Photographic images that have survived over the years provide anchors to the county's past. This book is dedicated to generations of photographers who have captured moments that document Cecil County's past and cultural heritage, providing a mosaic of county history.

CONTENTS

Acknowledgments 6

Introduction 7

1. Establishing 9

2. Passing Through 15

3. Making a Living 51

4. Serving 77

5. Enjoying, Relaxing, and Reflecting 105

ACKNOWLEDGMENTS

This book would not exist without the unlimited access I was given to the photograph collection at the Historical Society of Cecil County. Most images in this book are from this collection, and in the interest of simplifying and saving space, all photographs without a credit line are courtesy of the Historical Society of Cecil County.

The historical society provided more than photographs. Use of the extensive archives at the society provided invaluable content material for the captions, and the support from the board of trustees and my colleagues at the historical society was appreciated.

County historian Michael Dixon, former president of the Historical Society of Cecil County, shared his knowledge of the society collections and county history. Dixon also supplied Cecil County photographs from his own collection.

Diane Ehrhart, president of the Rising Sun Historical Preservation Committee (RSHPC), gave enthusiastic support to this project, provided some photographs from that committee's museum, and put me in contact with Joan Troat and other Cooney family members for background information on several photographs. Photograph credits to the Rising Sun Historical Preservation Committee are designed RSHPC.

Local Arcadia authors offered suggestions and answered procedural questions. These authors were Bill Bates, who has written several Arcadia books on Harford County topics, his latest on *Aberdeen Proving Ground*; Chris Knauss, who wrote *Maritime Cecil*; and Erika Quesenbery, who wrote *United States Training Center, Bainbridge*; Erika was a valuable contact for Port Deposit photograph questions.

Chesapeake City historian Lee Collins answered some questions about his town and helped answer additional questions indirectly through his Web site on Chesapeake City history.

I appreciate the guidance of Arcadia editors Lauren Bobier and Paul Joseph and the encouragement and support of family and friends.

INTRODUCTION

Cecilius Calvert, the second Lord Baltimore, gave Augustine Herman a large land grant as an initial payment for Herman's project to map the Chesapeake Bay region in detail. Herman named his estate Bohemia Manor to honor his family heritage. When Herman completed the map in 1670, he had literally put Cecil County on the map; it was not officially established until 1674. Herman had advocated for the county's creation out of Baltimore County, and perhaps this was one more persuasion tactic.

A border dispute between Maryland and Pennsylvania dragged on for years. The final resolution came with the arrival of English surveyors Charles Mason and Jeremiah Dixon. The Mason-Dixon Line divided Maryland and Pennsylvania and, less known, established Maryland's border with Delaware. For the nation, the Mason-Dixon Line symbolically divides the North and South. For Cecil, the line marks the northern and eastern border, making Cecil the only Maryland county with two Mason-Dixon Lines.

But boundaries do not eliminate occasional border confusion: Cecil County has produced more Delaware governors than Maryland governors; Cecil native George Read signed the Declaration of Independence for Delaware; a Cecil County school was a predecessor of the University of Delaware; Cecil is the only Maryland county in the Philadelphia Metropolitan Statistical Area; and entering the county from the Baltimore metropolitan area requires a toll on two out of three roads.

Late in the 17th century, the Maryland Legislature declared the Anglican Church the official church, making it the county's most powerful institution; other believers were tolerated as long as they paid taxes to the Anglican Church. The county court reflected the power of the official church. The first county court held meetings at Jamestown on the Sassafras River. In 1719, the county seat relocated to Court House Point, then Charlestown in 1782. In 1786, the state approved a new courthouse and jail at the Head of Elk (Elkton).

In the 18th century, grains became the dominant crop in a more diversified agricultural economy that no longer relied on tobacco crops. During the Revolution, grain production, location at the head of the bay, and a trade network with the rest of the Eastern Shore turned Cecil County into a supply depot for Washington's army.

As the war continued, the county accommodated American, French, and, reluctantly, British armies. In 1777, Howe's British army landed at Elk Neck to begin the Philadelphia Campaign. Lafayette's army marched through on the way to Virginia. Washington and Rochambeau's armies loaded heavy ordnance onto boats at Elk Landing and then dashed across the county and on to Yorktown to trap Cornwallis.

During the War of 1812, the British returned to local waters. Defenders repulsed a British attack on Elkton, but Principio, Fredericktown, and Frenchtown were destroyed.

Frenchtown quickly recovered. Trade goods destined for Baltimore and Philadelphia were transported by wagon across the peninsula between Frenchtown and New Castle. An all-water route opened when the Chesapeake and Delaware Canal was completed in 1829. To compete, the Frenchtown and Newcastle Railroad, one of America's earliest steam-powered

railroads, was created, but the canal and newer railroads made the Frenchtown and New Castle route obsolete.

Despite the decline of the Frenchtown route, Cecil County retained strong national transportation ties in the mid-19th century; the Chesapeake Bay, five rivers (one tapping the resources in the Susquehanna River Valley), a canal accessing the Delaware Bay, several major roads, an important East Coast railroad crossing the county, and a position midway between the country's second and third largest cities outside the New York City area brought a steady movement of commerce and people through the county.

The Philadelphia, Baltimore, and Wilmington Railroad had one main delay on its route, at the Susquehanna, where cars had to be transported by railroad ferry—first five cars at a time on the steam ferry *Susquehanna*, replaced later by the *Maryland* with a 21-car capacity. A severe winter had frozen the river so solid in January and February 1852 that horses hauled railroad cars across tracks on the ice. The event convinced the state legislature to allow a bridge, but bridge construction was delayed and finally completed after the Civil War.

The debates over slavery and the approach of civil war generated conflicting feelings among Cecil citizens. Fugitives escaping slavery moved cautiously through the county, some with help. Slavery had been declining in the county until Maryland made manumissions more difficult just before the Civil War. In 1860, free blacks in the county outnumbered slaves three to one.

The outbreak of the Civil War required immediate deployment of troops to protect Washington, but a Baltimore riot and destroyed bridges between the Susquehanna and Baltimore halted rail traffic. Cecil County became pivotal as troops on boats from Philadelphia were rushed through the canal, and trains continued carrying troops to Perryville for transfer to the *Maryland* and other steamboats for transport to an Annapolis rail line. After the immediate crisis ended, a flow of troops, munitions, and supplies continued through the county. Maryland wavered but stayed in the Union. Many Cecil Countians, white and black, joined the Union army, but some citizens headed to the Confederacy. The government organized a mule school at Perry Point and trained mules and teamsters there for about a year before the school was relocated. The federal government later purchased Perry Point during World War I for a nitrate plant and used the land after the war for a veteran's hospital.

Grain, paper, lumber, and iron mills stayed busy through the 19th century. Port Deposit quarries supplied granite for building projects in East Coast cities. Farmers and canners shipped out produce seasonally. Fisheries packed impressive amounts of shad and herring. Market gunners supplied ducks for city diners. However, transition into the 20th century brought economic change. The county's charcoal-based iron-making companies could not compete with steel corporations. Railroads made Port Deposit's role as a port of deposit unnecessary even before the construction of the Conowingo Dam for electricity. Overfishing ruined the fishing industry. International treaties ended commercial duck hunting. The quarries grew silent. The paper mills closed. Agriculture- and transportation-related businesses remained important but not without undergoing change.

The marriage and tourist industries provided extra income for some, but the Great Depression hobbled the county's economy.

World War II transformed the county. Fireworks factories like Triumph Explosives expanded into munitions factories and recruited in other states to find enough workers. Increased demand for housing triggered government housing projects. In the western part of the county, the former Tome School campus was converted into a naval training center. Cecil Countians in the military served proudly, like the ones that landed at Omaha Beach. Risk was not limited to war zones. Triumph had its own casualty list, with the deadliest explosion taking 15 lives in 1943.

Interstate 95 joined the list of major transportation arteries through Cecil County in the 1960s. Since the highway's opening, Cecil County has held the distinction of being the least densely populated county along the I-95 corridor between Washington, D.C., and Boston, but change happens. Over the ensuing decades, the interstate has revitalized the economy, spurred population growth, and contributed to an increasingly suburban look to this traditionally rural county.

One

ESTABLISHING

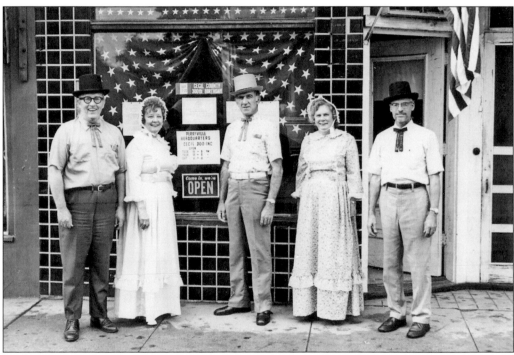

In 1974, Cecil County celebrated its 300th anniversary. Lord Baltimore had granted a large area of land between the Elk and Bohemia Rivers to Augustine Herman for undertaking the task of mapping the Chesapeake Bay region in detail. Augustine Herman named his estate Bohemia Manor to honor his family heritage. Herman encouraged his friend and patron Cecilius Calvert, the second Lord Baltimore, to separate the area from Baltimore County and name it after himself. Herman literally put Cecil County on the map, as the county appeared on his completed map several years before the county's official creation in 1674. A county committee and town committees coordinated events for the tercentenary celebration. The town committee for Perryville is pictured at their headquarters. From left to right are Morton Taylor, coordinator; Gertrude Hasson; James Thomas, chairman; Katherine Hasson; and Carleton Brown.

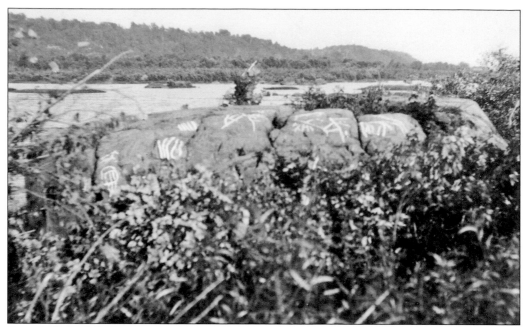

Petroglyphs at Bald Friar and artifacts along county waterways evidence Native American cultures long before Capt. John Smith explored the area and met Susquehannocks, Massowomeks, and Tockwoughs. Warfare, the spread of European diseases, and migration greatly reduced the county's Native American population by the beginning of the 18th century. The petroglyphs, with the exception of some that were removed for preservation, lie underwater behind the Conowingo Dam.

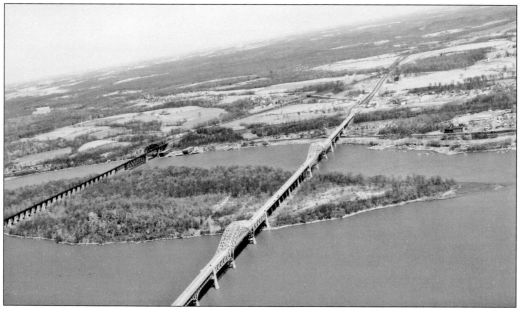

The earliest economic activity between Europeans and Native Americans within the boundary of what would become Cecil County was at Palmer's Island, later named Watson's and now Garrett Island, at the mouth of the Susquehanna River. In the 1620s, William Claiborne established a trading post on the island to trade with the Susquehannocks for beaver fur.

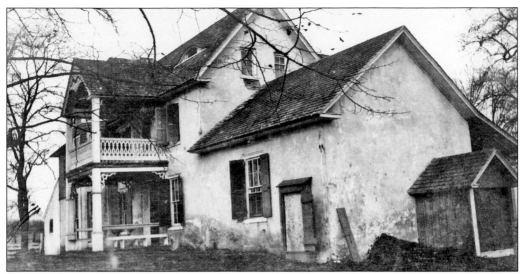

This long-abandoned farmhouse shown in an early-20th-century photograph was part of the Bohemia Manor estate. Lord Baltimore granted Augustine Herman 400 acres in 1662 and added more land to the grant after Herman completed the Chesapeake Bay region map in 1670. The manor house burned in 1815, but the name Bohemia is indelible in the area.

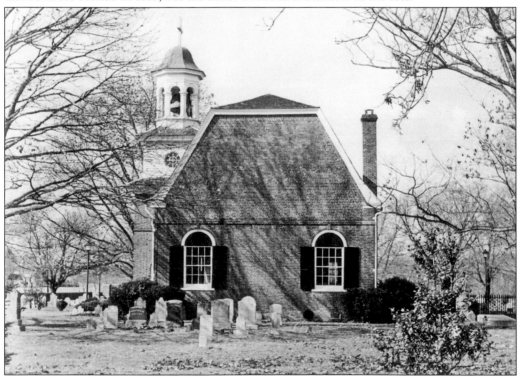

The 1692 Vestry Act divided Maryland into 30 parishes, declared the Anglican Church the official church, and required the colonists, church member or not, to pay a tax supporting the church. North Sassafras Parish was among the original parishes, and St. Stephens was the parish church. North Elk Parish was created in 1706, and St. Mary Anne's, pictured here, was built at North East for that parish in 1742.

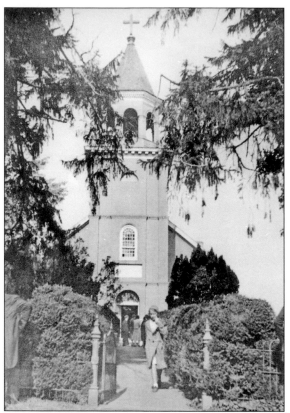

Jesuit missionaries established St. Francis Xavier, commonly called Old Bohemia. The church building dates back to the late 18th century. In 1745, the Bohemia Academy was created on the grounds. John Carroll, America's first Roman Catholic bishop and archbishop in America, attended the academy, and it is believed that his cousin, Charles Carroll of Carrollton, a Declaration of Independence signer, also attended it.

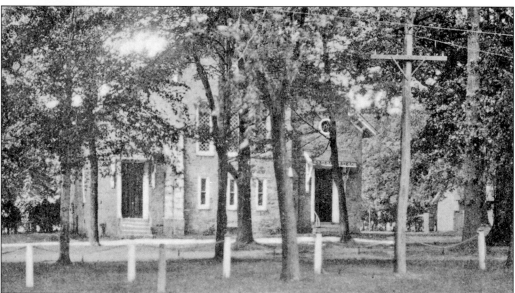

Ulster-Scottish Presbyterians added to the influx of settlers by the 1720s and founded churches near Fair Hill and at West Nottingham. The West Nottingham Presbyterian Church, pictured here, was built in 1800 and remodeled in 1857. The West Nottingham Academy, founded in 1744, educated two Declaration of Independence signers, Richard Stockton of New Jersey and Benjamin Rush of Pennsylvania. The academy is the oldest boarding school in the country.

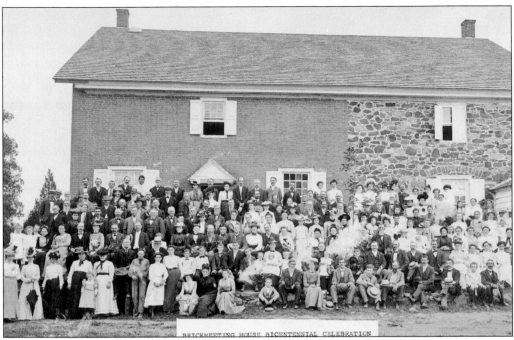

BRICKMEETING HOUSE BICENTENNIAL CELEBRATION

In 1701, William Penn, ignoring Maryland boundary claims, granted land stretching from Octoraro Creek to current-day Blue Ball and intruding well into Cecil County to Quaker settlers from Pennsylvania. The Nottingham lots included a section for a Quaker place of worship. The brick side of the Brick Meeting House in Calvert was constructed in 1724 and the stone side in 1749. The celebrants in this 1901 picture are commemorating the original meetinghouse grant.

Symbolically the Mason-Dixon Line represents the national divide between North and South. The Mason-Dixon Line, named for its surveyors, was surveyed from 1764 to 1767 to end boundary disputes between Maryland, Pennsylvania, and Delaware, with Cecil the only Maryland county shaped at both borders. Boundary stones were set every mile, and crown-stones, showing the coat of arms for the Calvert and Penn families, were set every five miles.

The early court had governing power and met on the north side of the Sassafras River at Jamestown, near Ordinary Point (labeled Old Town on the 1858 Martenet county map). In 1719, the county seat was moved to Court House Point and then relocated to Charlestown in 1782; Charlestown at Market Street is pictured.

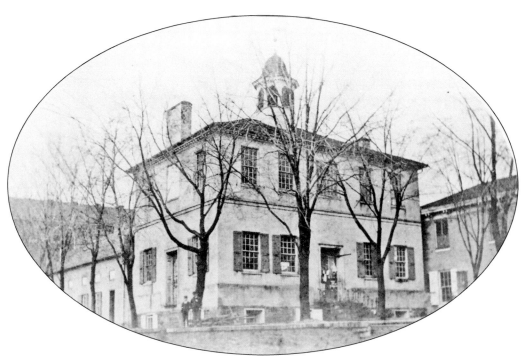

In 1786, the legislature approved building a courthouse and jail at Head of Elk, or Elkton. The courthouse was built in the following decade at the intersection of North and Main Streets and is shown here prior to its 1886 remodeling; a new courthouse constructed nearby replaced the older one in 1940. The older building is still used by the town.

Two

PASSING THROUGH

The opening of Interstate 95 updated and burnished Cecil County's historic role in the nation's transportation network. Since the Colonial period, rural Cecil County has accommodated the flow of trade goods and travelers, tourists, recreational visitors, dignitaries, military supplies, friendly armies, an invading army, the navy, and, for a time, romantic couples ready to be married, passing through on the county's waterways, highways, and railways. The Chesapeake Bay and the Chesapeake and Delaware Canal are major ship routes on the Atlantic Intracoastal Waterway, and until late in the 19th century, the Susquehanna River was an outlet for lumber, flour, and other Susquehanna Valley goods. U.S. Routes 40 and 1, like their predecessors dating back to the Colonial period, pass through the county. An important Colonial route through Warwick was one that George Washington liked to travel. The Frenchtown and New Castle Railroad was one of the nation's first railroads using a steam engine. The Philadelphia, Wilmington, and Baltimore Railroad, later absorbed into the Pennsylvania rail system, and the Baltimore and Ohio Railroad were major railroads crossing the county.

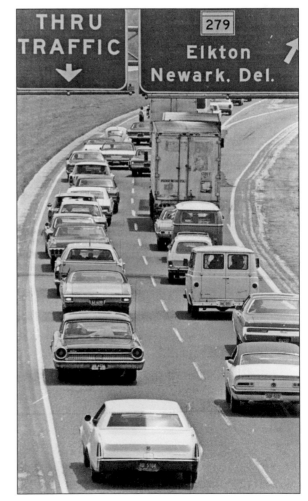

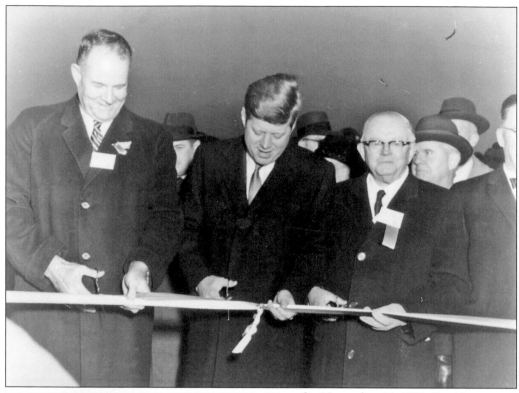

On November 14, 1963, President Kennedy, with Gov. Elbert Carvel of Delaware on his left and Gov. Millard Tawes of Maryland on his right, dedicated this section of Interstate 95. Originally called the Northeast Expressway, Maryland officials changed the name to the John F. Kennedy Memorial Highway. The highway stimulated the local economy, and nearly 30 million vehicles passed through the toll plaza at Perryville in 2005.

Austin Crothers, the last Maryland governor from Cecil County (1908–1912), was known as a reformer and the "Good Roads" governor. His push for hard surface roads resulted in Maryland creating a state roads commission to build and maintain a state-wide highway system, including a paved road network connecting all the county seats.

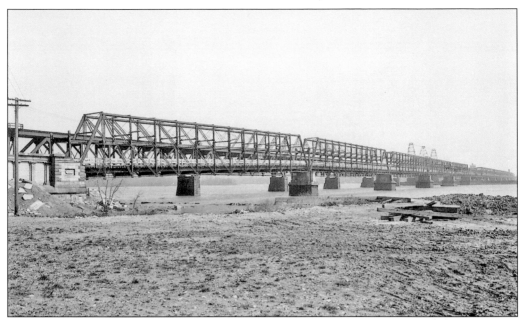

Before U.S. 40's realignment and the opening of a new bridge, this double-decker bridge connected Havre de Grace and Perryville at what is now State Route 7. After it was converted from a railroad bridge to a vehicular bridge in 1910, the state added a second deck in 1927 to improve traffic flow, but the low clearance was a problem for large trucks. It was dismantled during World War II.

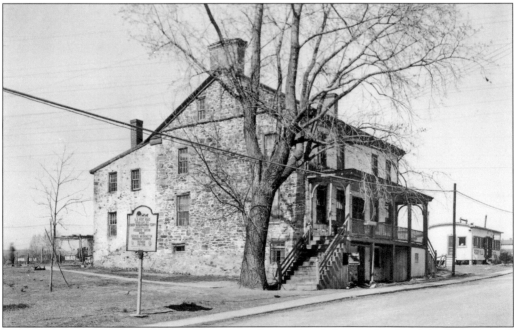

Rodgers Tavern, owned by John Rodgers, a militia colonel during the American Revolution, accommodated travelers in the Colonial and early national periods. George Washington stopped here often when traveling between Virginia and Philadelphia. In 1781, American and French forces crossed at the ferry located here in the rush to trap Cornwallis at Yorktown. Early-20th-century motorists stopped next door at the Boyd's Perryville Dinner for meals.

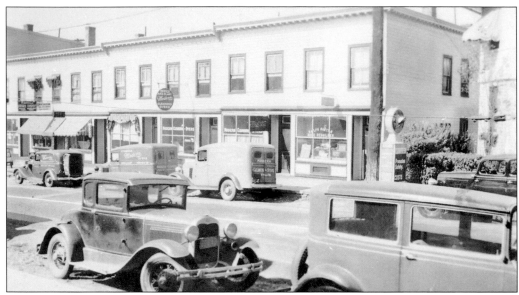

When U.S. Route 40 was realigned, in-town districts like this one in Perryville lost heavily trafficked thoroughfares and towns needed to reorient to stay vital. Businesses like the Perryville News Depot and Modern Cleaners and Dyers disappeared decades ago, but Perryville, North East, and Elkton have extended business activity along Route 40 and toward I-95.

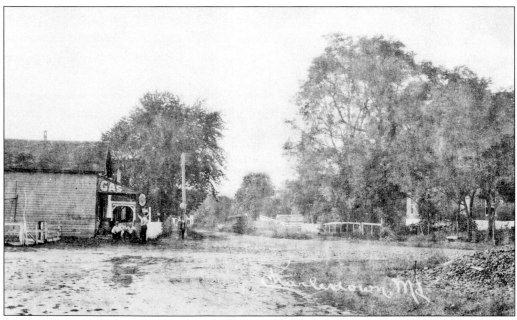

Colonial Charlestown, established in 1742, was a busy port and commercial center. During the Revolution, it served as a supply depot for the army. Washington ate and lodged there a number of times; Col. Nathaniel Ramsey, the hero at the Battle of Monmouth, lived there. In 1923, when this picture was taken, Charlestown was a resort town catering to duck hunters and beachgoers.

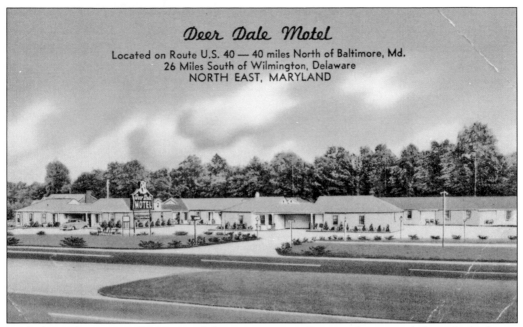

Deer Dale Motel

Located on Route U.S. 40 — 40 miles North of Baltimore, Md.
26 Miles South of Wilmington, Delaware
NORTH EAST, MARYLAND

With the realignment of U.S. 40 and the increase in traffic, motels appeared along the highway. Motorists coming from Baltimore would see the Deer Dale Motel as they approached North East. The Deer Dale Motel and many other Route 40 motels went out of business after the construction of I-95. Chain motels and truck stops near the I-95 interchanges have become more common in the county.

North East's Main Street is pictured in the first or second decade of the 20th century. Behind the group on the left is Dr. Phillip Housekeeper's Drug Store, where motorists could buy cans of gasoline. Traffic has become heavier in recent decades with visitors heading for Elk Neck State Park, other camp sites, marinas, gift shops, and restaurants. The Housekeeper's store building is now occupied by Saffron Creek Gallery.

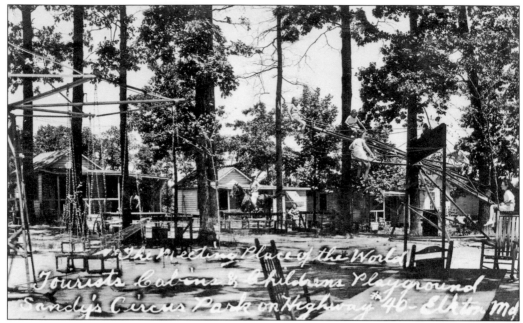

Between North East and Elkton on Route 7, Circus Park captured tourist dollars in the 1930s and 1940s and was managed by Sandy Tamargo. The back of this 1937 postcard declared Circus Park to be "where food and friendliness are the best" and "the meeting place of the world." An alternative name was the Elk River Indian Village, with "cowboys and Indians" performing on the site.

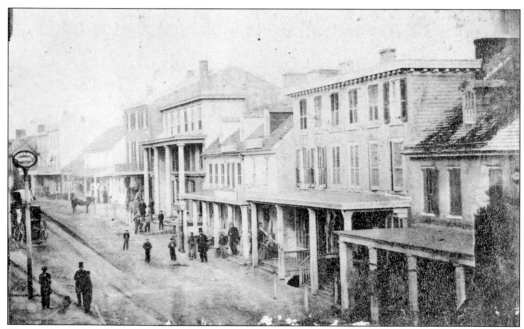

This is the earliest known photograph of Elkton's Main Street, around 1865. A sign for the Howard House is visible on the left. Outside of the New York City area, Philadelphia and Baltimore were respectively the nation's second and third largest cities in 1860, and Elkton was on the main route (U.S. 40 in the 1920s and 1930s) midway between the two.

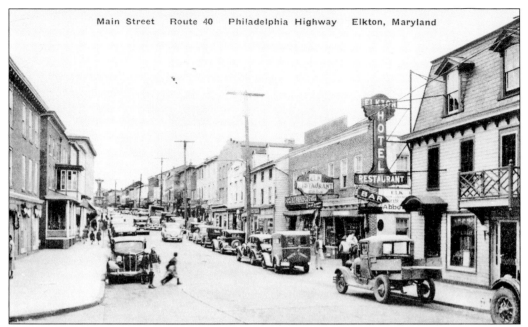

Main Street Route 40 Philadelphia Highway Elkton, Maryland

Motorists driving U.S. 40 between Philadelphia and Baltimore in the 1930s would see Elkton's Main Street as a busy stretch of road. They could stop at the Elkton Hotel, on the left, or the Elk Restaurant next door. Mac's Laundry trucks, like the one in front of the Elk Restaurant, did double duty, also serving as the forerunner of the library's bookmobile for patrons living along the delivery route.

For those travelers on U.S. Route 40 who preferred to leave the driving to others, they could have spent some time relaxing and tending to various wants and needs while waiting for the bus to pull out at the Greyhound bus stop at Lyon's Pharmacy on Elkton's Main Street in the 1950s.

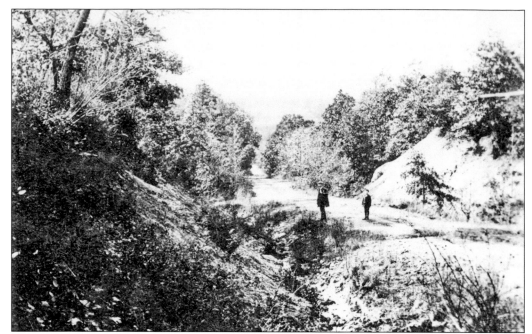

Philadelphia-bound travelers leaving Elkton in 1903 would encounter the road at Red Hill. Governor Crothers's familiarity with this road and other dirt roads in the county help explain his advocacy for hard surface roads when the automobile made its appearance. In 1904, Judge Albert Constable, a prominent Elkton citizen, was murdered by a robber while walking along this road.

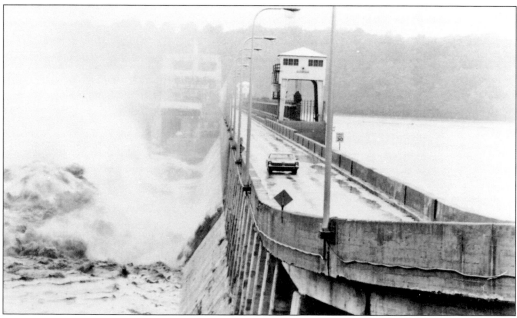

U.S. 1 crosses Cecil County's northern edge. In the 1800s, a covered bridge crossed the Susquehanna at Conowingo. An iron bridge replaced it in 1907; that bridge was blown up just before Conowingo was submerged behind the new dam. The dam doubles as a roadway. On the day this picture was taken in 1972, the approach of Hurricane Agnes made crossing over the dam trickier than usual.

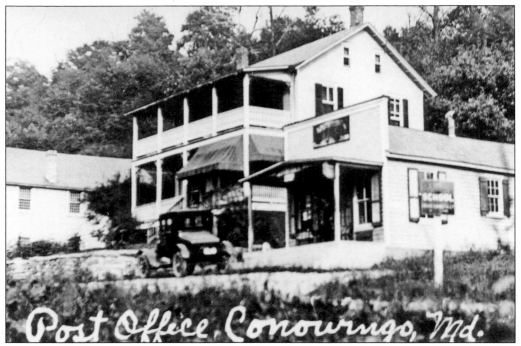

Post Office, Conowingo, Md.

The Conowingo Post Office, along with the rest of the riverside town, disappeared under the rising waters behind the newly constructed Conowingo Dam in 1928. The resilient town reseeded itself about a mile away on higher ground and regained a post office—zip code 21918.

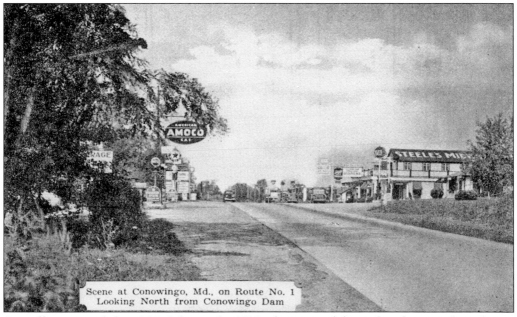

Scene at Conowingo, Md., on Route No. 1
Looking North from Conowingo Dam

As traffic increased along U.S. 1 during the 1930s, this postcard shows that the transplanted town of Conowingo sprouted businesses that accommodated motorists on the Cecil County side of the Conowingo Dam. Steele's Midway Inn was making reference to the equal driving distance between Baltimore and Philadelphia, suggesting it would make a good stop for a break and a meal.

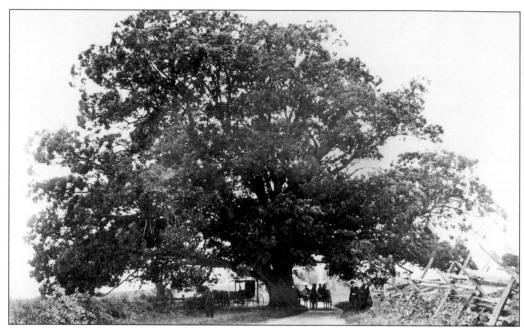

When General Lafayette's army marched across Cecil County in April 1781 to ferry the Susquehanna at Bald Friar and head south to Virginia to battle with Cornwallis, they camped near this oak tree, later named Richards Oak. When these visitors paused at the tree around 1915, it was still healthy. In the 1980s, time and storms brought it to an end, but a historical marker and remnants mark the site.

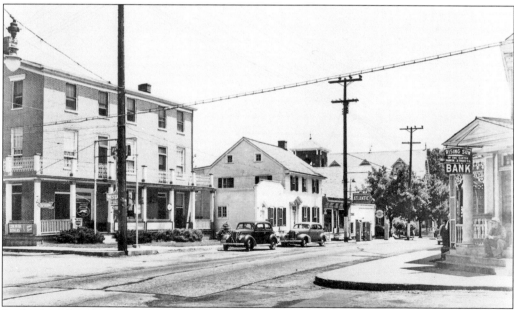

In the first decade of the 19th century, the village of Summer Hill occupied this spot. On the right in this 1940s photograph, the Rising Sun Bank stands where a popular tavern once stood. The tavern displayed a sign depicting a rising sun to symbolize its name; the renamed town of Rising Sun was incorporated in 1860. The Greyhound Lines sign on the right indicated bus service along U.S. 1.

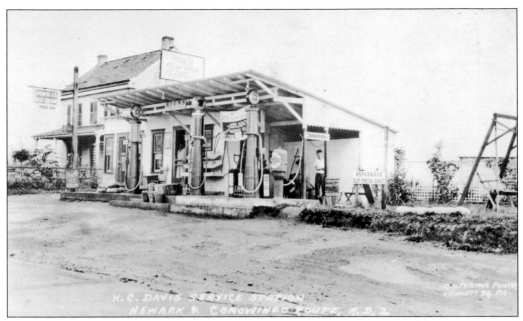

Along the Newark and Conowingo Route at Pioneer Filling Station, owned by H. C. Davis, a motorist could purchase gas, fresh cut or picked produce, and ice cream and have a sign painted. Davis was a truck farmer, store owner, and gas station owner, not an unusual combination in rural areas during the Great Depression.

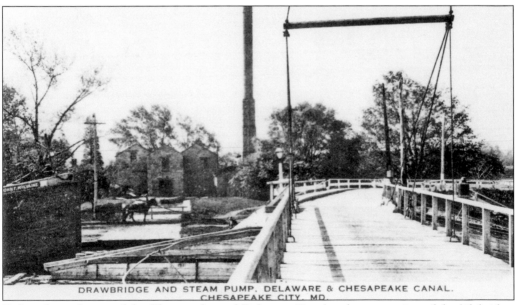

Before the widening of the Chesapeake and Delaware Canal and construction of the lift bridge, people traveling from Elkton on Route 213 would cross the canal lock over a draw or swinging bridge, locally called the high bridge, continue along the causeway, and then cross the long bridge into south Chesapeake City. The steam pump house is in the background on the left in this c. 1900 postcard.

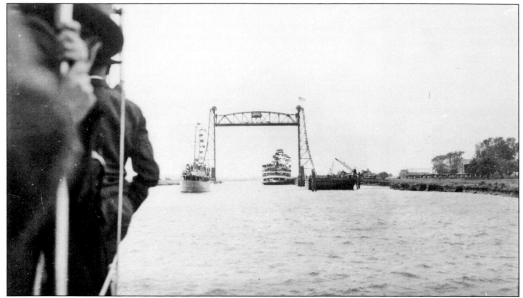

Raised for Chesapeake and Delaware Canal traffic in this scene, the lift bridge at Chesapeake City lowered for vehicles to cross on Route 213. Before the Chesapeake Bay Bridge was built in 1952, many Baltimore-area vacationers heading for Maryland's and Delaware's Atlantic beaches used this route through the Eastern Shore. The lift bridge opened in 1926, and an errant freighter knocked the bridge down in 1942.

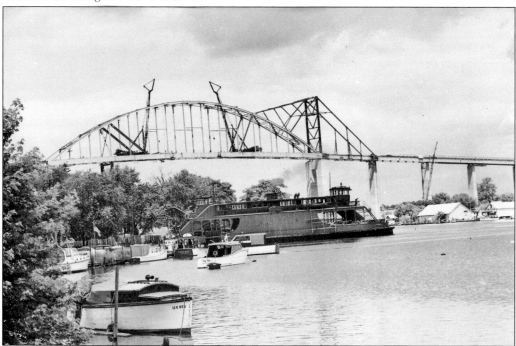

The ferry *Gotham* loads vehicles on board for the trip across the canal at Chesapeake City while the new Chesapeake City Bridge rises in the background. The tall stationary structure, opening in 1949, allowed both ship traffic on the canal and vehicle traffic on the rerouted 213 to flow without interruption and ended ferry service.

This Chesapeake City view from the lift bridge shows the Rio Movie Theater in the foreground on George Street at the First Street intersection. The bridge connected George Street in south Chesapeake City with the town's northern half at Lock Street. Also known as Bohemia Village when the canal opened in 1829, the town was officially named Chesapeake City in 1839. (Courtesy of Michael Dixon.)

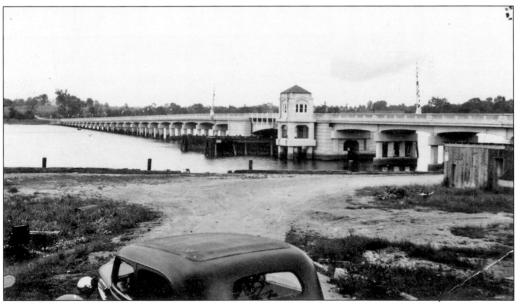

In the 1930s, a more substantial drawbridge had replaced a wooden structure over the Bohemia River. The Bohemia River was on the Bohemia Manor estate, owned by Augustine Herman and named for his homeland. The river divides into Great Bohemia Creek and Little Bohemia Creek. (Courtesy of Michael Dixon.)

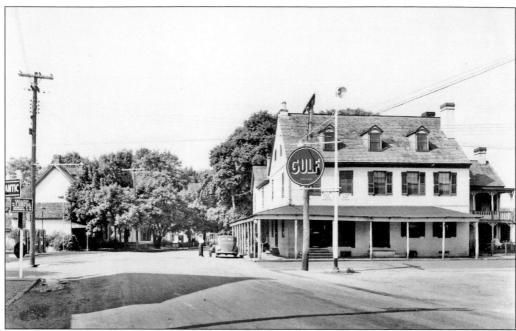

Previously known as Cecil Crossroads and Savinton, Cecilton was named for Cecilius Calvert and incorporated in 1864. Earlier attempts to establish a Cecilton in the county had failed. As the sign notes in this late-1930s photograph, above, tourists on Route 213 could turn here and drive seven miles to Crystal Beach, or they could select from a number of other bayside beaches once they passed Earleville, or they could turn north from Earleville and attend historic St. Stephen's Episcopal Church. The Sunoco station pictured below was an early Cecilton gas station photographed in the 1930s. Between 1912 and the appearance of service stations, motorists driving through Cecilton could buy gas at the Hoover's store.

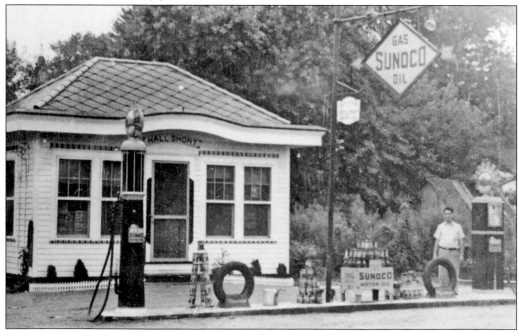

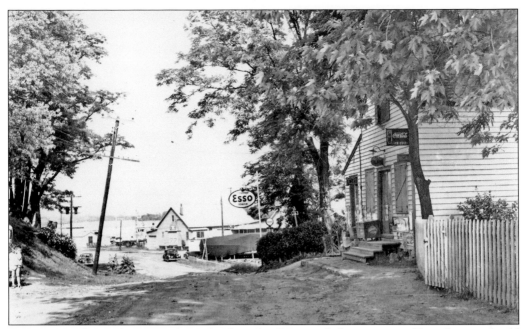

Motorists in the 1940s approaching the Sassafras River and about to enter Kent County would have this view of Fredericktown. Fredericktown, with the earlier names of Pennington's Point and Happy Harbor, was one of Cecil's earliest towns, established in 1736. During the War of 1812, British raiders burned Frenchtown and its Kent County neighbor, Georgetown.

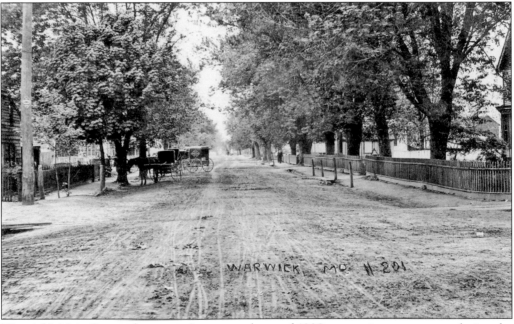

Warwick's Main Street, shown on this postcard around 1908, was an important route during the Colonial and early national periods. Wagons passed through Warwick carrying goods between harbors at Odessa (accessing the Delaware Bay) and Fredericktown (accessing the Chesapeake Bay). George Washington traveled this route on occasion, dined and lodged with the Heath family at Worsell Manor, and had a business representative in Warwick. (Courtesy of Michael Dixon.)

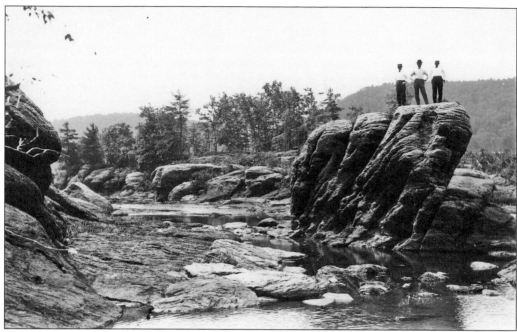

This *c.* 1905 picture along the Susquehanna River bed illustrates why the Susquehanna was a tougher river to navigate than the county's other four rivers. Despite the rocks, shoals, and submerged snags, the Susquehanna carried arks and rafts with grain, lumber, and other trade goods out of the Susquehanna Valley and initially on to Baltimore. Philadelphia merchants desiring to capture a portion of this trade supported building the Chesapeake and Delaware Canal across New Castle and Cecil Counties. The Susquehanna town that prospered as a port of deposit for processing these goods for reshipment to larger markets was aptly named Port Deposit. By the mid-19th century, Port Deposit was second only to Baltimore as Maryland's most active port. The convenience of railroads and the building of hydroelectric dams ended this trade early in the 20th century.

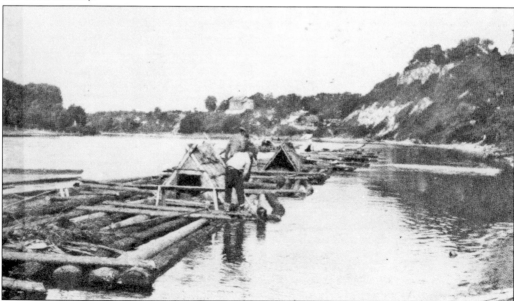

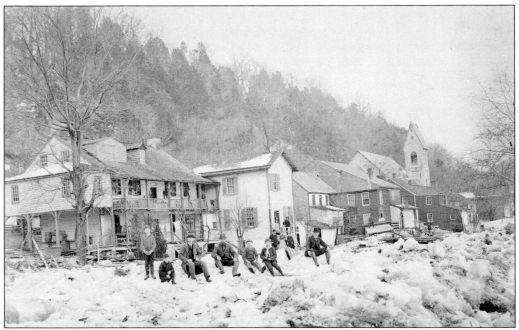

Not just trade goods passed through Port Deposit. Spring thaws released ice gorges that had built up on the river, and boulders and sheets of ice filled the streets, wrecked buildings, and became floods and mud. The above Main Street picture, with Tome Memorial Methodist Episcopal Church in the background, was taken either in 1904 or 1910, when the ice deposits were severe. When residents were not pausing to pose for pictures, they were busy removing chucks of ice from the street, cleaning up the mess, and repairing the damage. The Conowingo Dam ended the ice sieges, but nature has had other ways to test the resilience of Port Deposit residents; the most memorable was the flooding in the wake of Hurricane Agnes in 1972, when all the Conowingo flood gates were opened to reduce pressure on the dam.

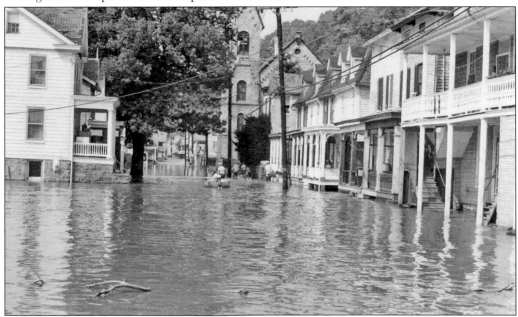

The boys sitting on the steps of this c. 1905 photograph of the square in Port Deposit are most likely students from the nearby Jacob Tome Institute. The store behind them and the one beside it were torn down for a new highway, later named the Jacob Tome Highway. The Gerry House is to the far right, and Alonzo Barry's photography studio is to its left.

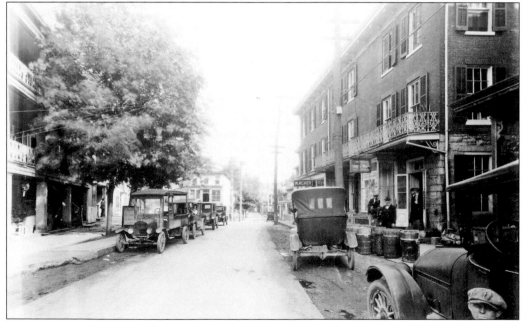

In this 1922 view of Port Deposit's Main Street, the Gerry House, with its ornate iron porch railing, is on the left side of the street, and the Winchester Hotel with its confectionery store is on the right. When Lafayette revisited the United States in 1824, he visited at the Gerry House. A drive along Main Street reveals many architectural uses of Port Deposit granite.

The Turkey Point Lighthouse, built in 1833, aided navigation where the Elk River widens into the Chesapeake Bay for ships approaching and exiting the Chesapeake and Delaware Canal. Fannie May Salter, peering down from the lighthouse platform, was the last keeper. When she retired in 1948, the lighthouse was also retired.

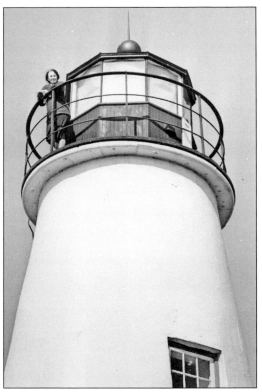

Elk Landing, a busy 18th- and early-19th-century port, traded goods with Baltimore by ships and with Wilmington via Christiana by wagons. During the Revolution, the landing served as a Continental Army supply depot and debarkation site. In the War of 1812, defenders at Fort Defiance and Elk Landing repulsed a British attack. In this 1930s photograph, Elk Landing Dairy is operating from the landing. (Courtesy of Michael Dixon.)

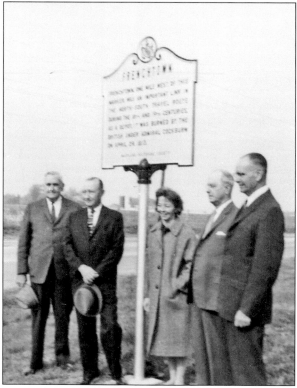

The quiet surrounding the Frenchtown Inn on the Elk River belies Frenchtown's 19th-century role as a port bustling with packet boats and steamboats engaged in trans-peninsular commerce between the Chesapeake and Delaware Bays and as a terminal for a turnpike that became the roadbed of one of the nation's first railroads, the New Castle and Frenchtown Turnpike and Railroad Company. The company needed to compete with the Chesapeake and Delaware Canal after the canal's completion in 1829. At the beginning of 1832, horses were pulling cars on a rail line; by the end of that year, steam engines had replaced the horses. In 1813, the *Chesapeake*, the Chesapeake Bay's first steamboat, started making scheduled runs to Frenchtown, despite the British burning the town just two months earlier. The Frenchtown historical marker, left, was dedicated in November 1964.

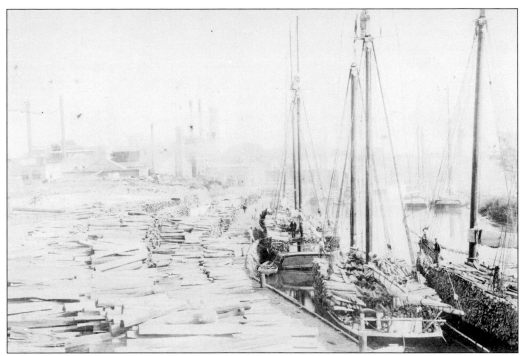

Here Elkton Harbor is crowded with boats laden with raw materials for operations at the Radnor mills and Scott Fertilizer Company. In 1919, the Radnor Pulp Mill had the daily capacity to process 75,000 pounds of pine pulp or 95,000 pounds of poplar and gum pulp for paper making. The wood came mainly from Maryland and Virginia. Silt and the bridge at Route 40 ended commercial river traffic at Elkton.

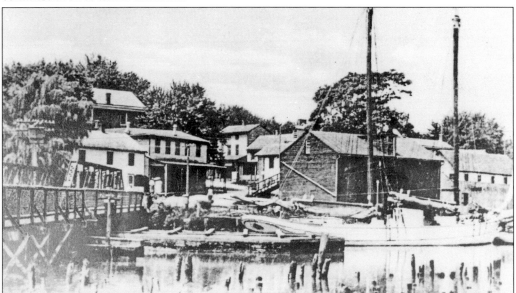

Chesapeake City was designed to support the commercial activities of the Chesapeake and Delaware Canal. This c. 1915 image shows the harbor and long bridge on the south side of Chesapeake City. From here, one could cross the bridge to the causeway, continue to the north end of the causeway, and take the swing bridge over the canal into the north side of town.

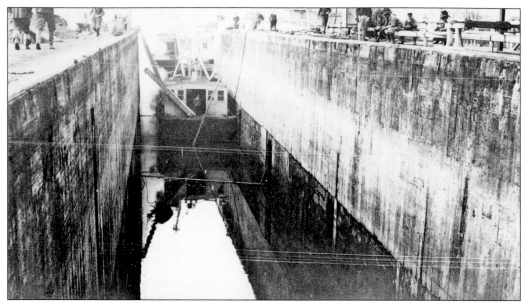

The Chesapeake and Delaware Canal opened in 1829, shortening shipping time between Baltimore and Philadelphia and facilitating Susquehanna trade to Philadelphia merchants. But as ships became larger, the narrow locks restricted trade, peaking at 1,318,712 tons in 1872. Nevertheless, the national government recognized the canal's strategic value. In the Civil War's early weeks, when rail traffic between Baltimore and Washington was disrupted, steamboats rushed troops and supplies through the canal to Perryville for transport down the Chesapeake. After rail service was restored, the canal remained important to the war effort, and it was again during World Wars I and II. In 1919, the federal government purchased the canal, removed the locks, and deepened and widened the canal; the work intermittently continued after the canal was reopened in 1927. Ships transport over 10 million tons of freight annually on the canal.

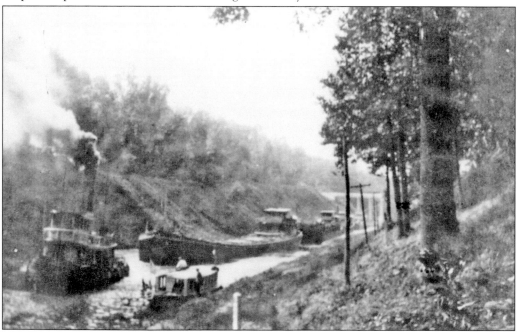

In 1937, the Historical Society of Cecil County participated in dedicating the James Rumsey historic marker near Rumsey's birthplace at the head of the Bohemia River. Rumsey is credited with inventing an early steamboat, which he successfully demonstrated on the Potomac River at Shepherdstown in 1787. He died in 1792, just before he was to demonstrate an improved model. Fulton's later commercial success with his steamboat obscured Rumsey's accomplishment.

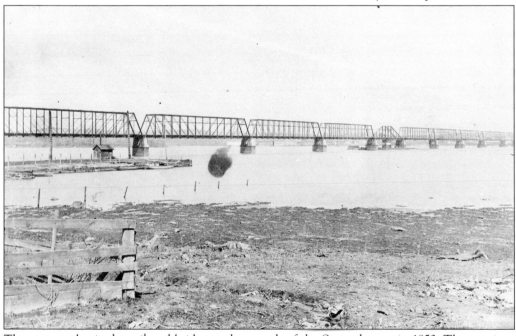

The state authorized a railroad bridge at the mouth of the Susquehanna in 1853. The previous year, the Susquehanna had frozen so solid that the railroad ferry was locked in ice, and track was laid across the ice for horses to pull railroad cars across. After delays, the bridge was built in 1866. In 1880, the wood superstructure was replaced with iron. The bridge was later converted for automobile traffic.

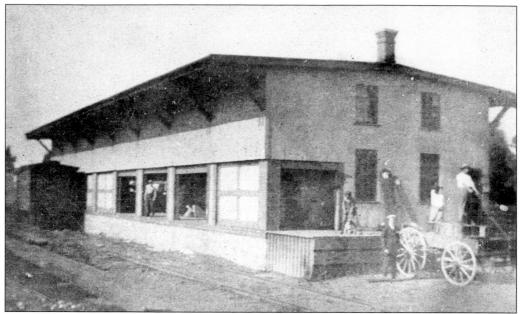

In addition to its location on the mainline of the Philadelphia, Wilmington, and Baltimore Railroad, Perryville was the terminal for the Port Deposit Branch line, which connected with other railroads. Shipment transfers between railroad lines would take place at this Perryville freight station around 1900. The Pennsylvania Railroad gained ownership of the Philadelphia, Wilmington, and Baltimore Railroad (also known for a while as the Philadelphia, Baltimore, and Washington Railroad).

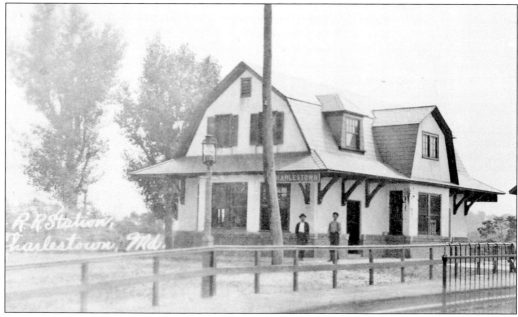

Heading east from Perryville, the next station was Principio Furnace, the location of the Whitaker Iron Company. Charlestown was the next stop, the station located at the northeast end of town at Route 7 and the west side of 267. A Victorian-style station burned in 1913 and was soon replaced by the station in this view.

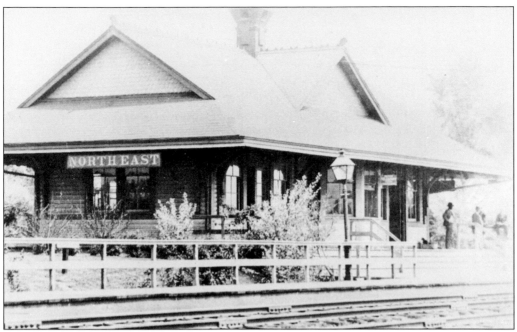

Next on the mainline was the North East station, located on the north side of town east of Main Street, and the freight office to the west of Main Street. A sign for the telegraph office hangs beside the door in this c. 1910 view. In the 19th century, the McCullough Ironworks had a spur line near the station. The next station before Elkton was at Bacon Hill.

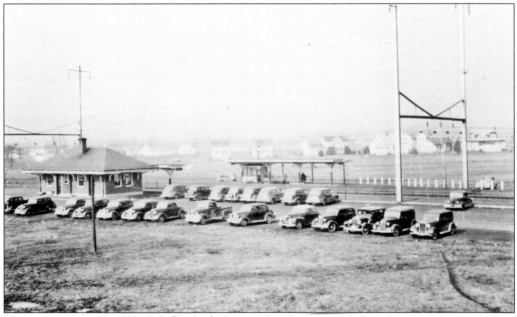

These cars parked at Elkton's Pennsylvania Railroad station on Bow Street in the late 1930s reveal only a portion of station activity. Up until around 1938, many arriving couples exited the station for the courthouse to get a marriage license. Railroad passenger service at Elkton stopped in 1971, was briefly resumed by Amtrak, and then ended again in 1982. Elkton's first station was along Railroad Avenue. (Courtesy of Michael Dixon.)

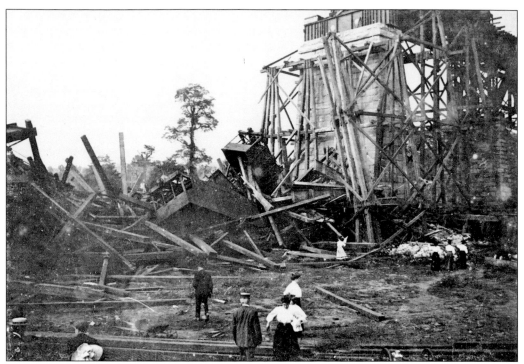

In September 1908, twelve coal cars hurled into the Susquehanna River and adjacent shoreline when the Baltimore and Ohio Bridge over the Susquehanna collapsed. No one was seriously injured, but the wreckage became a local attraction for sightseers. One county newspaper reported that hundreds of people visited the site each day.

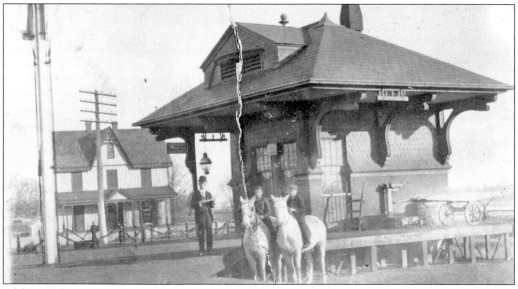

Although known as the nation's first successful railroad, the Baltimore and Ohio arrived in Cecil County in the 1880s relatively late. This scene at the Aiken station around the beginning of the 20th century would sharply contrast with the bustle of the 1940s. When the U.S. Naval Training Center at Bainbridge opened in 1942, sailors and recruits jammed this station and the nearby Perryville station.

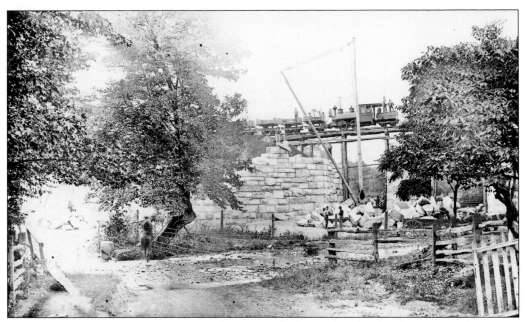

Construction crews worked along the Baltimore and Ohio Railroad right-of-way across the county preparing the new line to Philadelphia. In 1883–1884, workers constructed this stone bridge at Cedar Corner at Perryville. The bridge is still recognizable at the entrance to Cedar Corner Road from U.S. Route 40.

For years, Baltimore and Ohio Railroad travelers between Philadelphia and Baltimore during Christmas season spotted a decorated 55-foot holly tree at Jackson Station. The railroad promoted the Travelers Christmas Tree and, beginning in 1948, held festive tree-lighting ceremonies. The annual event was covered on radio broadcasts and television news. The company claimed that over 56,546 visitors saw the tree in 1954. Local groups have revived the tradition.

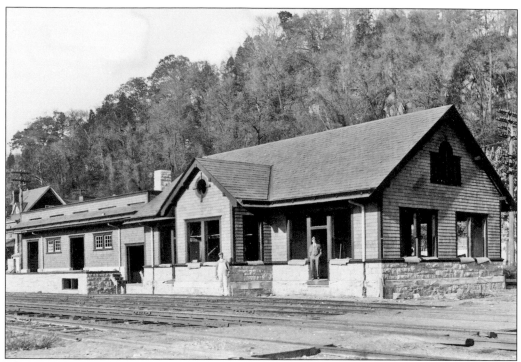

This view shows the Port Deposit Railroad Station nearing completion in 1905. Port Deposit linked to several rail lines—the branch line from Perryville; the Port Deposit and Columbia Railroad, running along the Susquehanna River; the Baltimore and Philadelphia Central, linking Port Deposit with the Rising Sun area; and the Octoraro Branch.

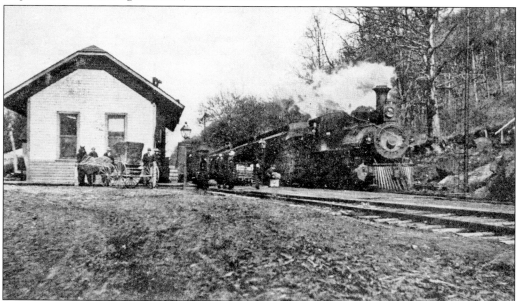

The steam engine in this view is pulling out from the station at old Conowingo, around 1900, on the Port Deposit and Columbia Railroad. In the 1920s, just before the town was flooded behind the Conowingo Dam, the railroad track was relocated to higher ground. (Courtesy of Michael Dixon.)

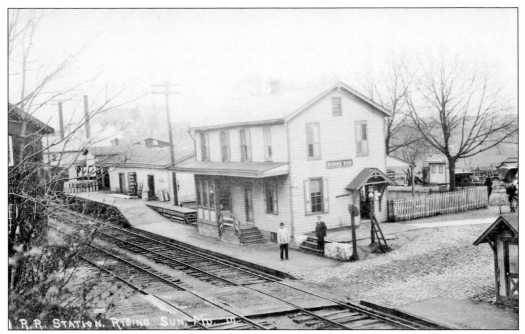

The Philadelphia and Baltimore Central Railroad arrived in Rising Sun from the Philadelphia end in late 1865, followed by connections to Port Deposit and Baltimore and an Octoraro Branch line. Residents were pleased that agricultural products from the area could now reach larger markets. Notice the milk containers from the condensery stacked on the back of the station platform in this c. 1910 image. (Courtesy of Michael Dixon.)

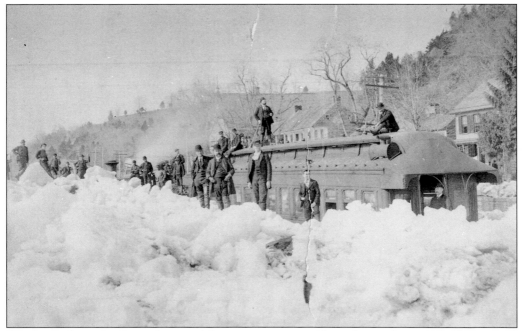

Ice gorges along the Susquehanna did not just create problems for residents along the river, as these delayed travelers on the Port Deposit and Columbia Railroad discovered in 1904. At least they had it easier than the work crews wielding picks and shovels to clear the track ahead.

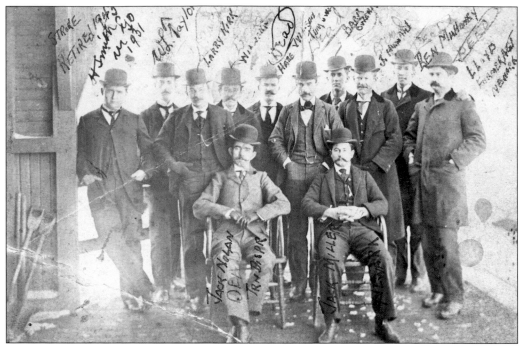

Telegraphs lines along railroad lines matched rapid communications and speedy transportation. Baltimore and Ohio telegraphers and dispatchers from Cecil County and New Castle County posed for a photograph in 1896, and someone noted their names and updated information on this copy. William L. Taylor, second from the left, was a dispatcher at Aiken and retired in 1954 at the age of 80.

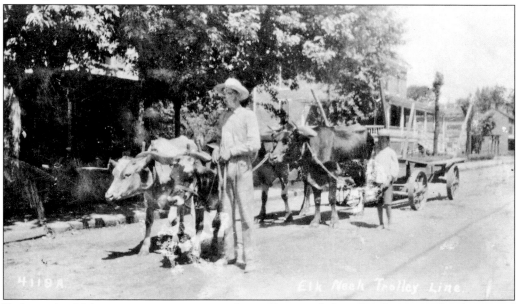

Early in the 20th century, towns were making all sorts of plans for electric trolley lines, and companies formed for this purpose. None of the plans materialized, but someone saw the humor in these grandiose plans and labeled this postcard the "Elk Neck Trolley Line." Evidently this line was to connect the isolated farms of Elk Neck with the "Greater North East Area."

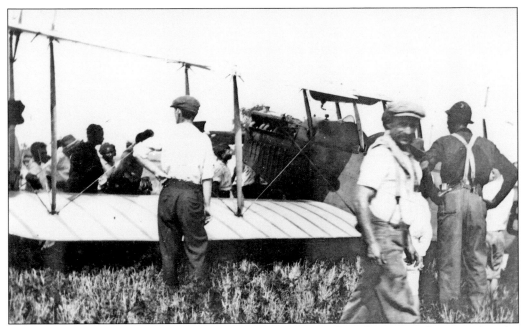

The airplane debuted in the Elkton area in August 1918, and residents were showing up at the Truite farm north of the old fairgrounds to get a closer look. Two planes flew in from Aberdeen Proving Ground, the pilots visiting a fellow aviator, Lt. Howard Bratton Jr., who lived in Elkton. To the delight of crowd, the pilots performed some aerial displays.

If a traveler passing through in 1909 decided to leave a main route and risk the rougher rural back roads, he may have entered villages like Mechanics Valley, northeast of North East. In the second half of the 19th century, when this village acquired its name, "mechanics" referred to people with occupations involving manual labor or a trade. The town's post office was discontinued in 1903. (Courtesy of Michael Dixon.)

Someone taking a drive off a main highway could expect to see mill towns like Providence, Elk Mills, Childs, New Bridge, and Rowlandsville. Providence was the location of the Kenmore Paper Mill and is shown in this postcard photograph from around 1910. Providence lost its post office in 1914. (Courtesy of Michael Dixon.)

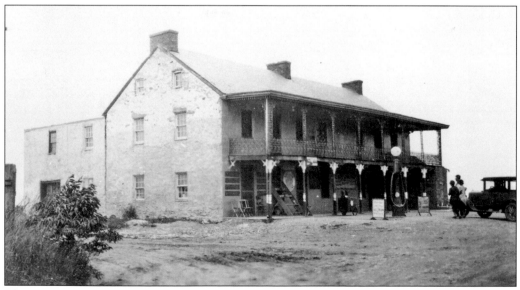

These motorists in the county's northwest corner around 1920 are at Rock Springs Hotel, built around 1825. In the mid-19th century, the hotel was the Gibson Inn or Tavern. For travelers going through rural areas in the 19th century, the identity of the town and the tavern sometimes blurred, leading to community names like Blue Ball, Rising Sun, and Battle Swamp (battle is an archaic term for cattle fodder).

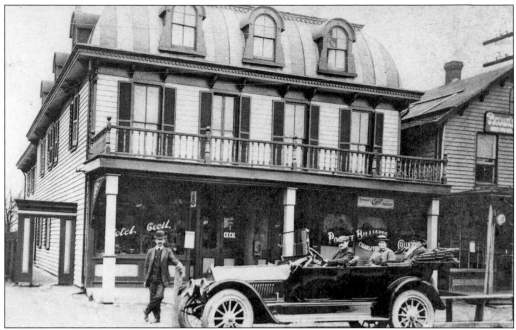

For recreational visitors, the Hotel Cecil, located on Main Street in North East, advertised itself as the "headquarters for ducking, crabbing and fishing" in a 1919 *Cecil Whig* special edition that featured this photograph. A. Wells, the proprietor, added at the bottom of the advertisement, "The above hotel is for sale." Later generations knew this building as Cramer's Department Store, and current tourists know it as an antiques store.

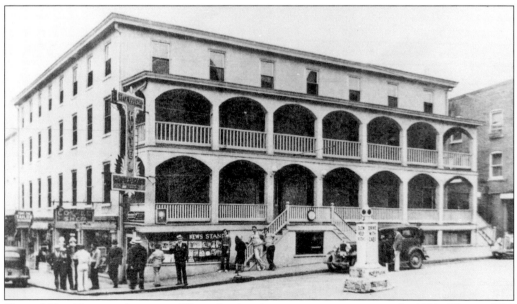

Howard Hotel has stood out as an Elkton landmark since its construction in the 1850s. This *c.* 1930 photograph shows the newsstand, coffee shop, and other shops around the ground floor. A 1919 advertisement pointed out the hotel had "All Modern Conveniences—Steam Heat, Electric Lights and Direct Phone." Other amenities were hot and cold baths and access to an attached garage.

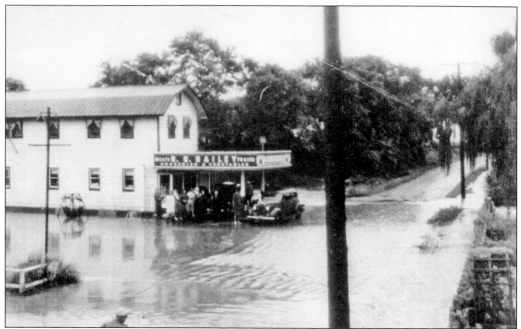

Port Deposit is not the only Cecil County town where a traveler might have trouble passing through after a torrential storm. Howard Street in Elkton and the intersection of Main Street and Route 7 in North East are prone to flooding. This 1945 picture shows North East's Main Street at what is usually a small run at the south end of town.

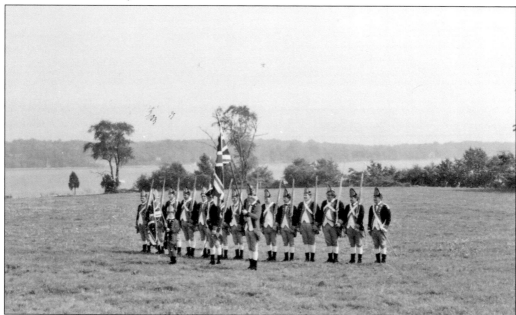

Among those passing through, the most unsettling was the British army, twice. In 1777, a British invasion force landed at Elk Neck to begin the Philadelphia Campaign. During the War of 1812, the British harassed the upper bay region; in Cecil County, they burned Fredericktown and Frenchtown and destroyed the ironworks at Principio. The attack on Elkton was repulsed. In 1977, re-enactors marked the 200th anniversary of the British landing.

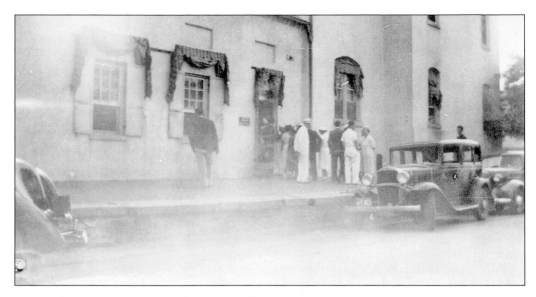

Among those passing through, the most publicized were romantic couples. Longer waiting periods for marriage licenses in the densely populated states northeast of Maryland sent many couples searching for the first courthouse they could find in Maryland, and they found it at Elkton. In the 1920s and 1930s, couples seeking marriage licenses formed long lines at the courthouse, above, and cab drivers picking up couples at the train station guided them to one of the numerous "marrying parsons." Some people in town expressed displeasure with the "marriage mill." Elkton's reputation as the place to get married was well entrenched, and when the marriage laws in Maryland changed in 1938 to require a 48-hour waiting period, the reputation lingered for years. Even the couple in the play *Guys and Dolls* announced they were rushing off to Elkton to get married.

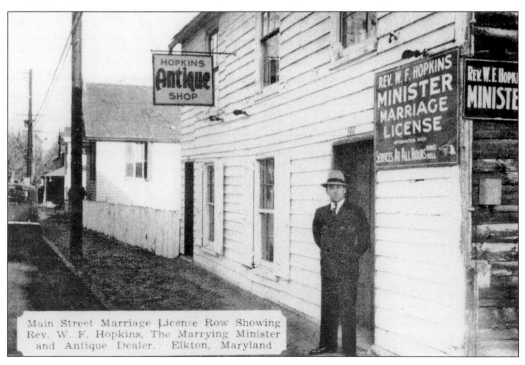

Main Street Marriage License Row Showing Rev. W. F. Hopkins, The Marrying Minister and Antique Dealer. Elkton, Maryland

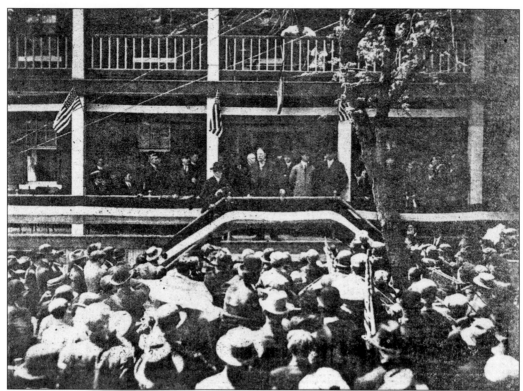

William Howard Taft spoke at the Howard House, joining a list of presidents, future presidents, and ex-presidents appearing in Cecil County. The roster may be incomplete, and some visits are better documented than others, but they include Washington, Jefferson, Madison, Jackson, Van Buren, Lincoln (briefly stopped at the Elkton train station), Grant, Cleveland, Theodore Roosevelt, Hoover, Truman (he did not actually stop, he cruised on the canal), Kennedy, and Nixon.

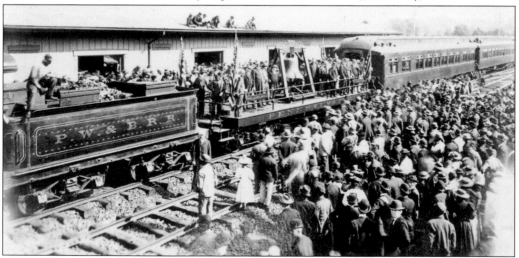

One celebrity passing through was inanimate. The Liberty Bell made a series of tours from the 1880s to 1915 to various cities for special events and passed through the county at least twice. In this picture taken at Elkton, the bell was en route to Atlanta for the Cotton States and Atlanta Exposition in 1895 (one plaque on the open car has Atlanta written on it).

Three

MAKING A LIVING

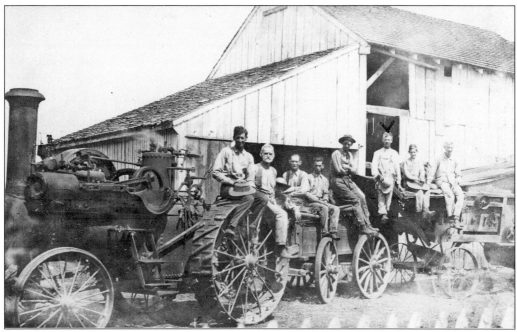

On the Holt farm near Union Church, the Holt family and workers pose with a steam farm engine and related equipment around 1910. Joseph Holt, the farm owner, is identified with a "V" mark over his head. After tobacco growing faded out in Cecil County before the Revolution, grain crops for Philadelphia and Baltimore markets became important. Grain remained the primary farm product, but rich and diverse soils have yielded a variety of crops and supported the raising of livestock. In the 1800s, until hit by blight, peaches were an important crop in the area between the Sassafras and Bohemia Rivers; Cassiday's Wharf on the Sassafras was loaded with crates of peaches for transport by steamboat to nearby markets. For generations, agriculture has dominated the county's economy. Recent population growth and a more diverse economy are changing the county's agricultural character, but agriculture remains important. Cecil County had over 77,000 acres of farmland in 2002, close to 35 percent of the county land area.

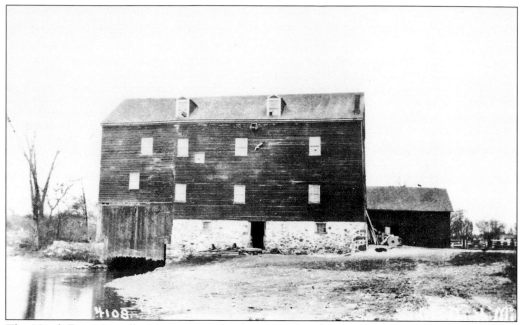

This North East gristmill with a cooper's shop on the right, photographed around 1910, was located in North East and last known as the Armstrong mill. With grain crops so prevalent, gristmills, and merchant mills, capable of larger production runs, were found throughout the county. At the beginning of the 19th century, 53 grain mills operated in Cecil County.

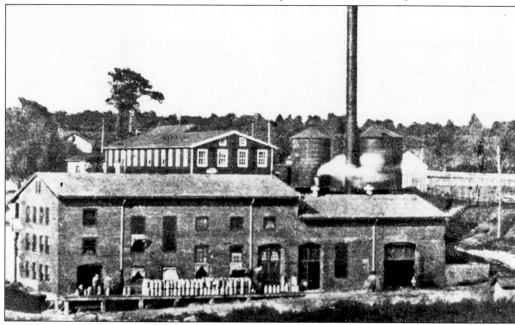

P. E. Sharpless built a condensery in 1906 in Rising Sun and contracted with local farmers for milk. In the 1920s, Sheffield Farms owned the business and shipped bottled milk to New York City. In the 1940s, Western Maryland Dairy shipped bulk milk to Baltimore for bottling. The plant was sold to Raymond M. Guethler and Sons of Rising Sun for local production and closed in 1979. (Courtesy of RSHPC.)

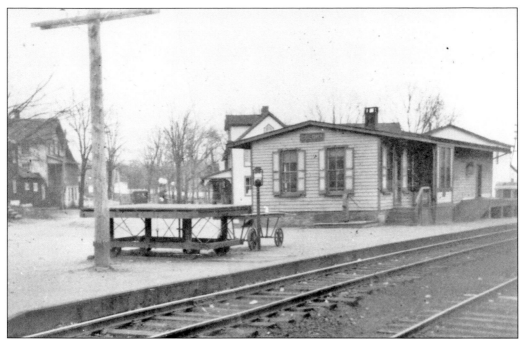

Farmers in isolated villages like Colora had limited access to markets. When the Philadelphia and Baltimore Central connected Colora with larger towns, new markets opened. Truck farmers sold their vegetable to canneries built near the station and shipped out fresh produce. A Colora fertilizer plant also benefitted from the access to a railroad. (Courtesy of Michael Dixon.)

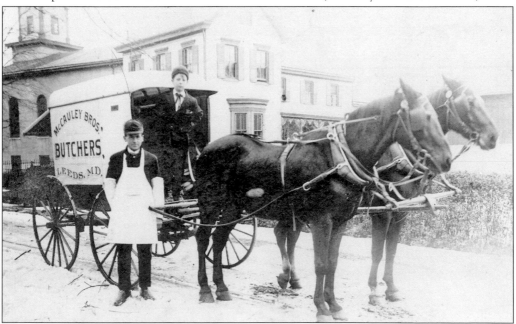

In Leeds, the McCauley brothers made the rounds in this c. 1900 butcher's wagon. A local historian noted that Robert L. McCauley would tether his horse and wagon at Bow and Main Streets in Elkton on Saturday nights, set up an oil-filled lantern above his scales, and sell the meats he had freshly butchered. (Courtesy of Michael Dixon.)

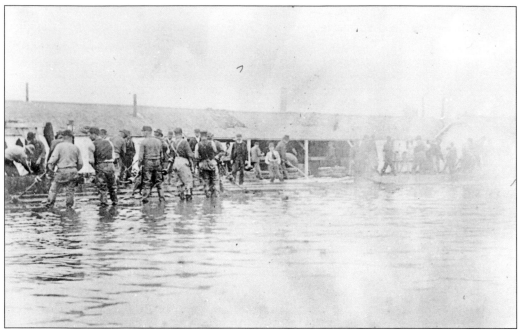

Starting in the 1820s, Susquehanna fisherman constructed large rafts or floats with makeshift shelters that were anchored on the river with stretches of seine nets for catching fish, like the float above from around 1905. Spawning shad and herring and the abundance of other fish in the upper bay and the county's rivers kept fisherman busy from March to June. Fishing batteries, like the battery at Cranberry Point on the Sassafras River (pictured below), lined the county's rivers. The seasonal nature of fishing made it primarily a source for supplemental income rather than a full-time occupation. Overfishing collapsed commercial fishing in the upper bay early in the 20th century.

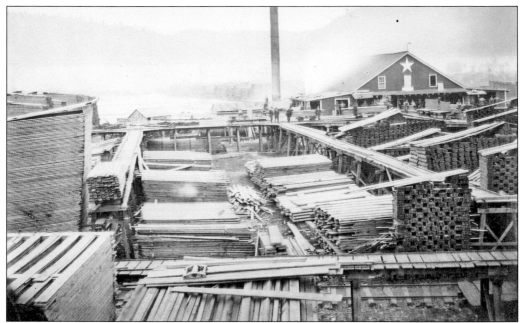

In the 19th century, the forests of New York and Pennsylvania along the Susquehanna watershed brought lumber and prosperity to Port Deposit. In the last quarter of that century, railroads changed the pattern of trade, not just for lumber, but for other Susquehanna regional products, ending the town's role as a port of deposit for processing and reshipping lumber and other goods.

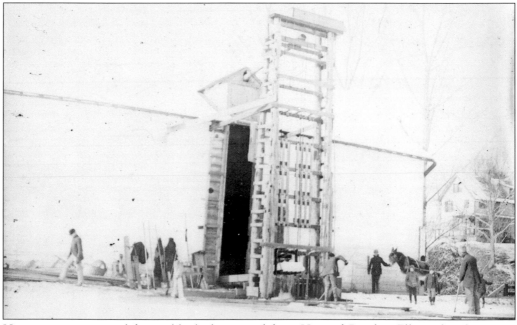

Here a steam engine lifts ice blocks harvested from Howard Pond in Elkton for placement in the icehouse, where the ice would be insulated for later use. The operation ended around 1915 when an ice plant was built on Delaware Avenue and began manufacturing ice. An ice harvesting operation on the Susquehanna ended in 1906 when the American Ice Company plant at Perryville burned.

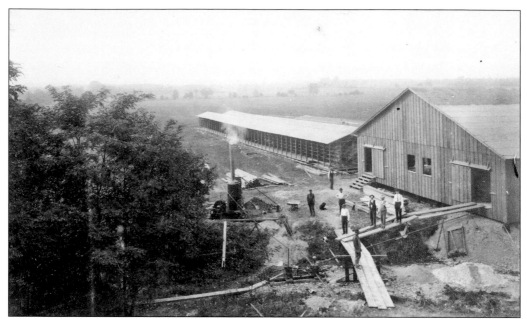

The American Clay Company was a Philadelphia company that built this plant near North East, around 1906, to take advantage of the area's high quality clay, suitable for making firebrick and pottery. The long building behind the plant is the drying shed. Thirty men were employed at the plant. Counting the American Clay Company, at least five companies in the North East area produced brick in 1906.

Henry Schofield Jr., shown here at his kiln near Rock Springs, was one of the county potters using area clay deposits to produce earthenware and stoneware for local customers. Schofield, born in 1861, was a potter's son. He established the Rock Springs pottery in the 1880s, and he continued to make earthenware until the 1940s. He occasionally took a break from making utilitarian pieces to create more artistic works.

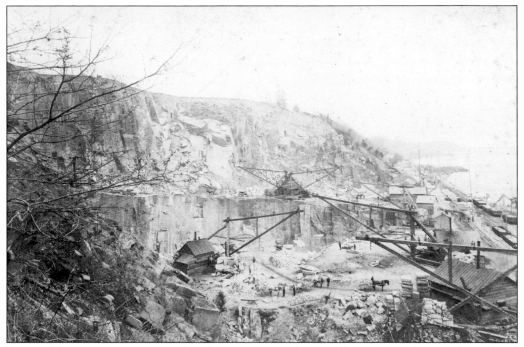

For roughly a century, quarrying Port Deposit granite from the Susquehanna hillside thrived and the distinctive bluish-gray "everlasting granite" fortified buildings, bridges, and other structures in East Coast cities large and small. Visitors to Port Deposit will easily find examples of the town's eponymous stone. The quarry photograph was taken around 1900.

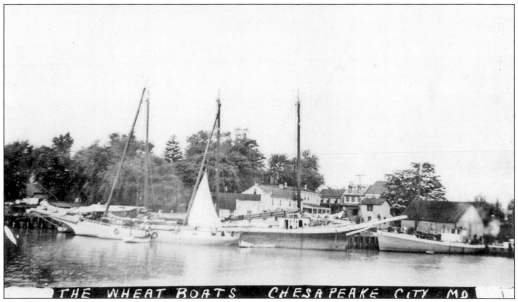

Transportation-related occupations became common in some communities. The wheat boats pictured here around 1910 are stopped at Chesapeake City. An 1828 canal report on the town's purpose called for erecting warehouses and buildings for persons engaged in the business and service of the canal, the accommodation of watermen, and all who may stop on their way to and from market. (Courtesy of Michael Dixon.)

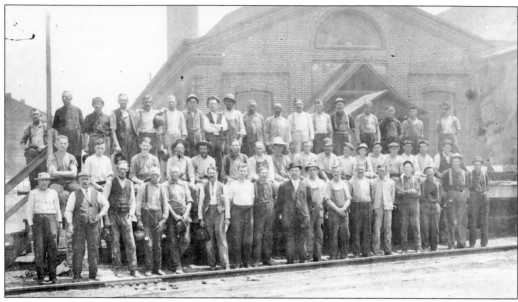

Workers at the Perryville roundhouse gathered for this photograph around 1915. A Pennsylvania Railroad main line joined by a Port Deposit branch line connected to a network of other railroads, and the nearby Baltimore and Ohio Railroad at Aiken turned Perryville into a railroad town. Like other communities, the roster of workers contained familiar Cecil County names mixed with the names of immigrants, now also familiar county family names.

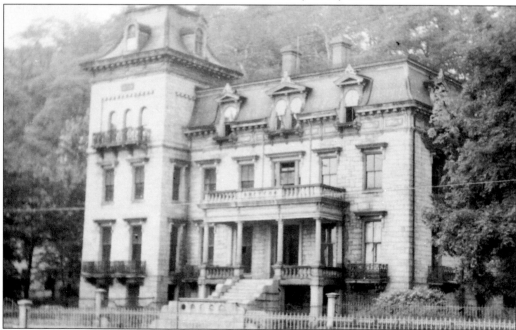

The Tome Mansion at Port Deposit testified to Jacob Tome's wealth, wealth generated mostly from transportation-related businesses. He initially profited from the lumber business, processing and reshipping lumber arriving at Port Deposit from the Susquehanna hinterlands. He successfully invested his profits in steamboats and railroads. He established the Jacob Tome Institute to provide education for local youth and left an endowment for a boys' boarding school.

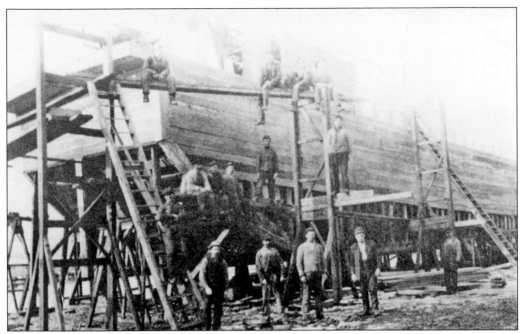

In 1902, about 45 skilled and rough carpenters, caulkers, blacksmiths, machine operators, and laborers employed at Deibert Boatyards at Elk Landing built seagoing and inland barges, mostly for Baltimore and Philadelphia buyers. Needing a deeper harbor, the boatyard relocated to Chesapeake City in 1911 to build canal barges and employed 90 to 100 workers. In 1913, the business was sold to Southern Transportation. (Courtesy of Michael Dixon.)

Constructing tubes for the Fort McHenry tunnel in Baltimore was one of the last projects at Wiley's in Port Deposit. Wiley's was one of three boatyards in the county during World War II; the Lancaster Iron Company, located near Perryville, assembled prefabricated sections and operated until 1950; the Berg Boat Company, awarded the U.S. Navy "E" for excellence in 1942 for its output of navy barges, was in Fredericktown.

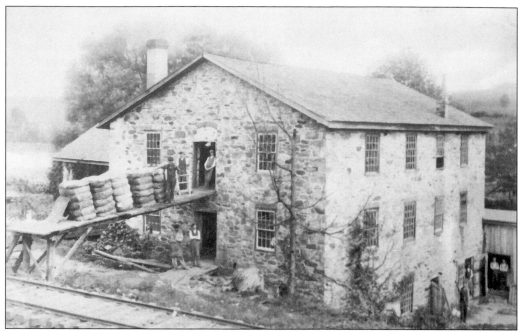

Originally a cotton mill when built by John Wilson near Leeds in 1811, this mill was purchased in the 1830s by John Harlan, who added a match-box paper mill at the site while continuing to manufacture cotton textiles. His two sons produced bookbinder pasteboard at the site. Fire destroyed the paper mill in 1911. The branches of Elk Creek and Northeast Creek were favored locations for paper and textile mills.

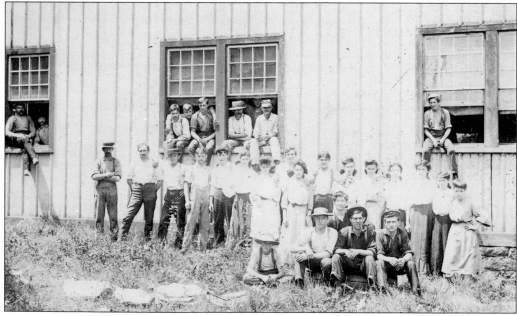

Kenmore Mill was known earlier as Providence Mill. In 1881, William Singerly bought the mill through a stock company he owned to make paper for his newspaper, the *Philadelphia Record*. In 1919, the mill produced about 85,000 pounds of paper daily, employed 200 workers, and operated six days a week. A Baltimore and Ohio branch line connected the plant with the station at Childs.

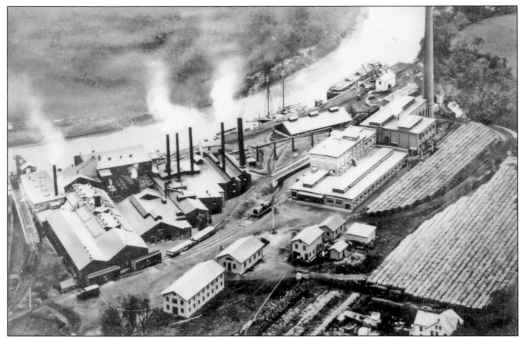

William Singerly owned the Radnor Pulp Mill complex in Elkton as well as the Kenmore Mill. After wood was processed into pulp at Radnor, the pulp was sent to Kenmore for conversion into various grades of paper. The Jessup and Moore Paper Company acquired the mills, and by the 1920, approximately 250 people were employed at Radnor.

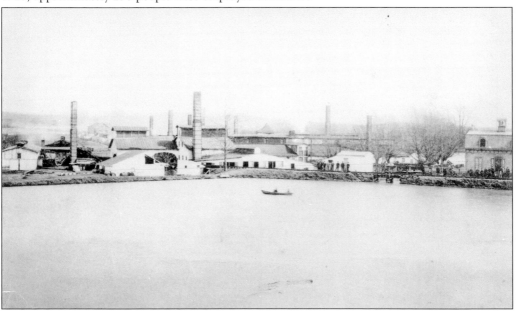

McCullough Iron Company manufactured galvanized and sheet iron in the second half of the 19th century. Starting in 1847 with their principal works at North East, pictured here in the 1880s, the company added works at Amwell, Rowlandsville, and in Delaware. In 1893, despite controlling the bulk of the nation's galvanized sheet-iron trade, the company could not compete with steel manufacturing and closed.

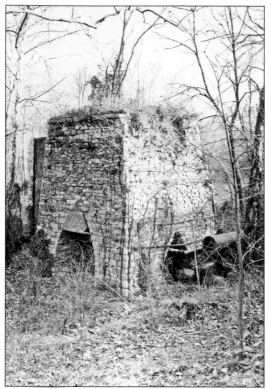

Cecil County's first iron furnace was Maryland's first. The Principio Company, a few years after its founding in London in 1620, built an iron furnace by Principio Creek. After the American Revolution, another company, Cecil Furnace, occupied the site, built a new furnace, and manufactured iron products, including cannons. During the War of 1812, the British destroyed the furnace and the cannons on site. In 1837, the Whitakers purchased the site and built the third furnace, pictured at left, the only furnace still at Principio. George Price Whitaker became the largest landowner in the county in the 19th century, buying up property for the trees to make charcoal for furnace fires. Coal-fueled blast furnaces producing steel made the Principio works obsolete. A fourth furnace at the site was dismantled. The undated photograph below shows forges at the site.

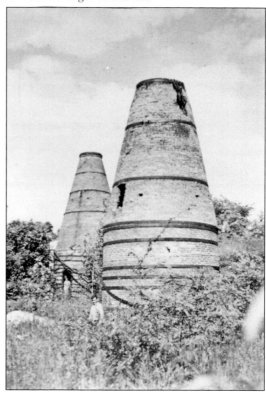

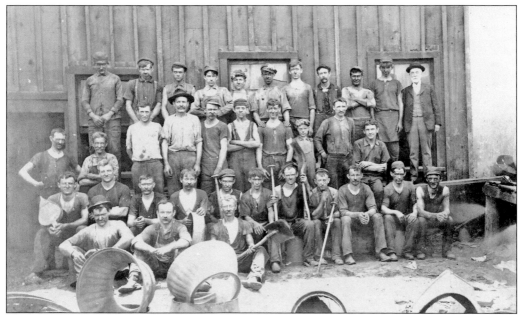

Workers at the Armstrong Stove Company in Perryville break from their grimy work to pose for this photograph around 1900. After the castings in the foreground have been cleaned and polished, the workers will assemble them into stoves for sale to mid-Atlantic markets. Ranges and heaters were also manufactured in the plant. The company closed in 1951.

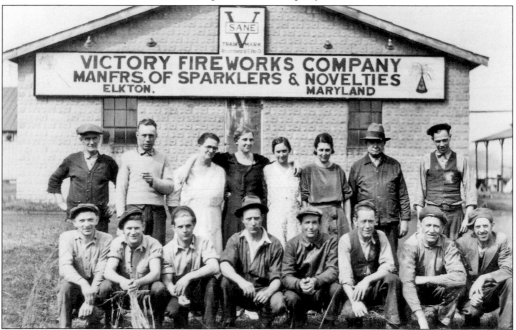

In 1919, Joseph Ben Decker founded Victory Sparkler and Specialty Company on West High Street in Elkton, pictured here in 1936. Several fireworks manufacturers located in the county, attracted by the availability of black powder at the DuPont Company in New Castle County. During World War II, fireworks plants in Cecil County converted to munitions manufacturing, with Triumph, partly owned by Decker, becoming the largest in the county.

Larger communities often had several general stores in the days before supermarkets and specialty stores. In Perryville, one general store was that of A. (Arthur) H. Owens and Brother, established in 1893 on Front Street, pictured here around that time. In addition to groceries and dry goods, game and fish were available in season.

Even a small community might have a general store, like the Taylor Brothers Store, photographed at Blythedale around 1905. The store also housed the village post office, a common combination in the 19th and early 20th centuries. The store was in business from 1850 to 1955; the post office closed in 1933. The Historical Society of Cecil County possesses some artifacts and manuscripts from the store.

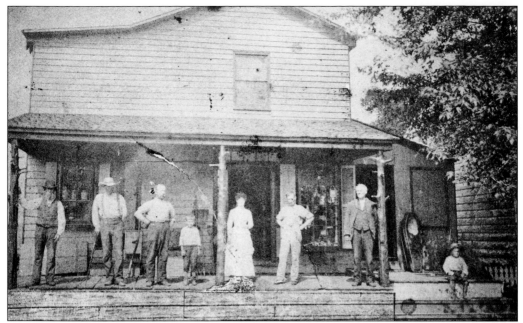

In order to make an adequate living, store owners like William Grant, standing on the right in front of his store in Cherry Hill around 1880, relied on multiple occupations. Grant's store included a cabinetmaking machine shop. Notice the child's coffin on the right; like many 19th-century cabinetmakers, William Grant was the local undertaker. William's wife, Mary, is standing at the center post.

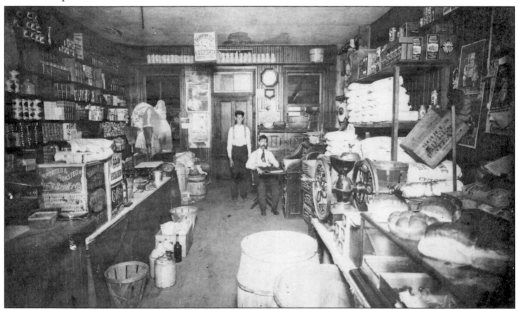

Brothers George and Benjamin Davis's grocery store, shown around 1900, was located on East Main Street in Elkton. The older brother, Benjamin, is seated at the desk. In addition to selling national brands like Heinz "57" and Dr. Hess's Instant Louse Killer, they stocked local products; the flour bags stacked on the right are from Cyclone Mill at Childs. Around 1921, George acquired a dry goods store on Main Street.

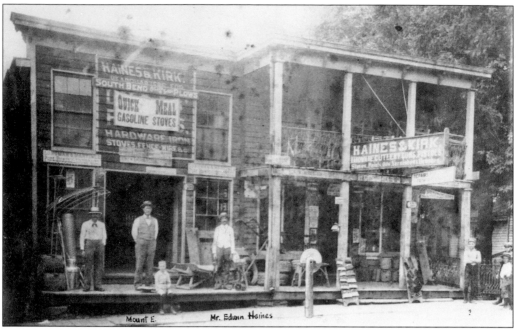

Haines and Kirk Hardware Store in Rising Sun was established in 1875, and as the signs indicate, it carried products and services expected in a farming community. Mount Kirk, standing in the doorway, and Edwin Haines, standing to the right of Kirk, owned the store. During the town's centennial celebration in 1960, the store was recognized as the town's oldest; it closed just a few years later. (Courtesy of RSHPC.)

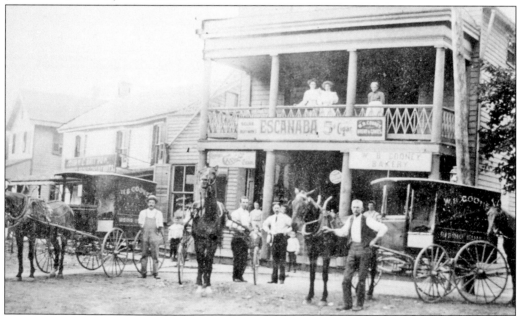

The Cooney Bakery, photographed in 1902, was located at Center Square at Pearl and North Queen Streets in Rising Sun and owned by Walter B. Cooney. The business did well enough that the sign over the store no longer advertised bowling and pool (in the basement). Walter Clooney sold the bakery and in 1915 bought the Maryland House, a Rising Sun hotel and restaurant.

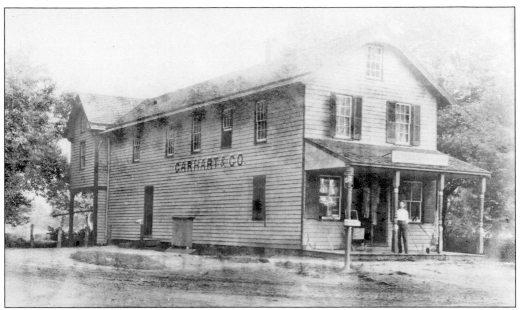

Advertisements for the Carhart and Company Store in Zion in the mid-1870s revealed the array of goods a shopper could expect to find in a village general store—dry goods, groceries, boots, shoes, hats, patent medicines, hardware, carpet chains, wood and willow-ware, and house furnishing goods. One advertisement promised quick sales and small profits; another advertisement specified the terms, cash on delivery.

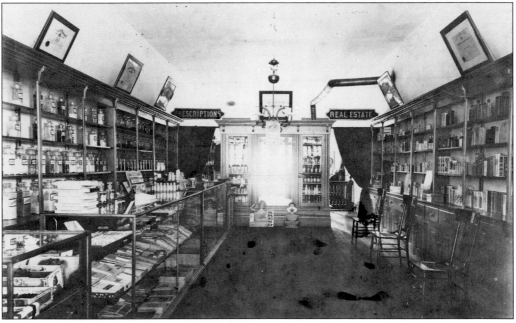

At Charles Beatty's Drug Store on Main Street in North East, shown around 1900, one could either fill a prescription or buy real estate. After Beatty died in 1906, a county newspaper reported that his daughter Annie, a registered pharmacist, planned to run the business and a few months later reported that her brother, Dr. Arthur W. Beatty, bought the business for $1,900, plus $100 for the stock of drugs.

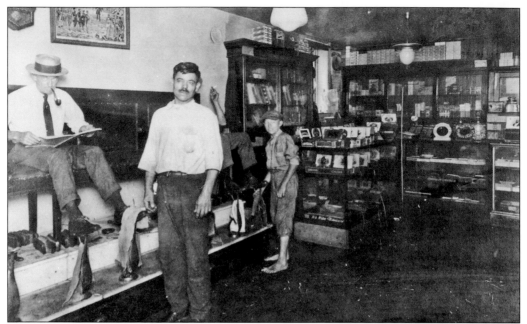

In Elkton around 1919, one could stop for a quick shoe shine at James Kargangis's Shoe Shine Parlor and buy a cigar before walking across North Street to the courthouse. If someone had more time, he could shoot some pool in the shop. Kargangis is standing in the foreground, and the customer on the left is believed to be William Freeman, an Elkton cab driver.

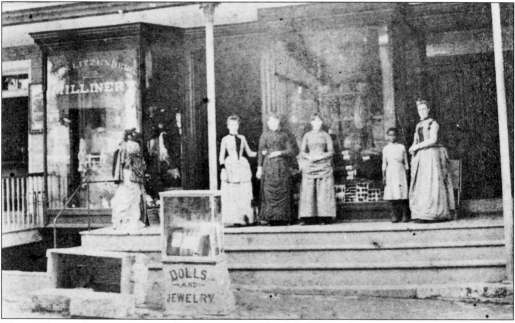

The millinery shop was a typical business owned by female merchants in the 19th century. In a May 1886 advertisement, Lucy Lutzenberg invited people to see her "handsome store" on Main Street in Elkton: "Come inside, and I will show you that the interior is even more attractive than the outside." In addition to millinery goods, the store sold dolls, toys, and games. (Courtesy of Michael Dixon.)

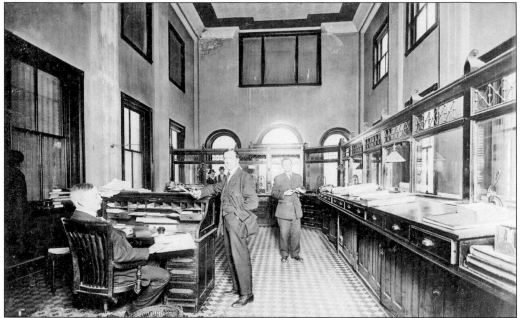

The Second National Bank of Elkton was located on North Street. In this *c.* 1914 view, Col. Isaac D. Davis, the cashier, is seated at the desk; William T. Warburton, the bank president, is standing beside the desk; and George E. Brown, the teller, is standing on the right. During the Civil War, Corporal Davis was commissioned a colonel when he agreed to command a unit of U.S. Colored Troops.

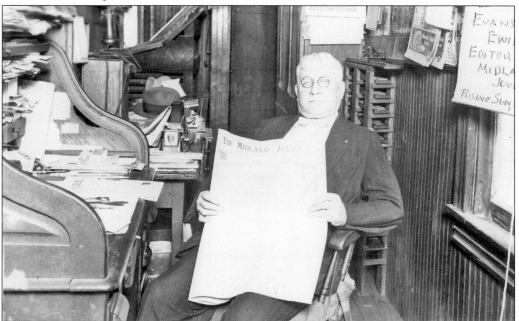

Evans Ewing, editor of the weekly *Midland Journal* in Rising Sun, looks like the stereotypical small-town editor in his office in 1923. The newspaper ended independent publication in December 1946. The *Cecil Whig* continued publishing the *Midland Journal* as a section in their newspaper for several years.

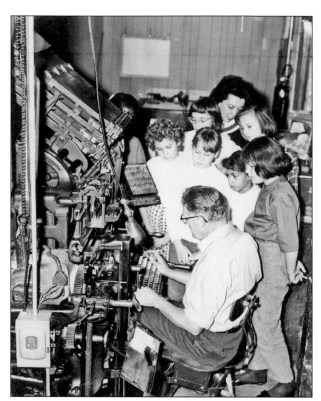

The Whig Party was short-lived, but the *Cecil Whig*, the county's party newspaper, founded in 1841, survives. Palmer C. Ricketts, the paper's first editor, is considered the most colorful, jabbing the opposition with a sharp, eloquent pen. The most famous incident erupted in 1843 when the editor of the *Cecil Democrat*, Amor Forwood, took exception to taunts from Ricketts and threatened to physically attack him. When Forwood attacked Ricketts with a cane on the street, Ricketts fatally shot him; the jury acquitted Ricketts, and he continued as editor for nearly two more decades. In the picture (left) from the 1970s, Ted Brown, the *Cecil Whig* linotype operator, demonstrates linotyping to a group of elementary school students. The 1970s photograph below shows the Whig Building on North Street. The mid-19th-century building was used until 1960.

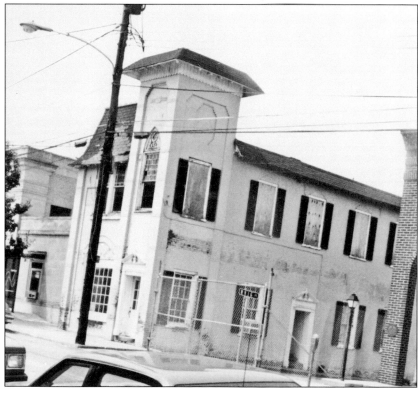

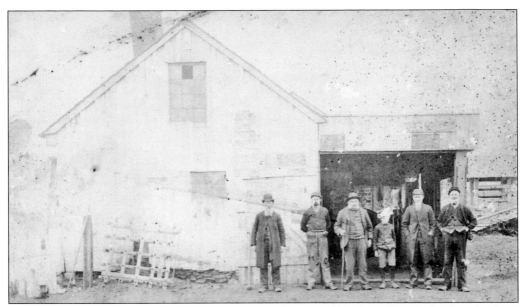

David Work and his son Joseph Work owned this Cherry Hill blacksmith and wheelwright shop, shown as it would have appeared around 1880. The people in the photograph are unidentified, and a defect in the photograph appears to account for why the boy looks like a serious smoker. David Work died in 1906, around the same time the horseless carriage was signaling the impending demise of village blacksmiths.

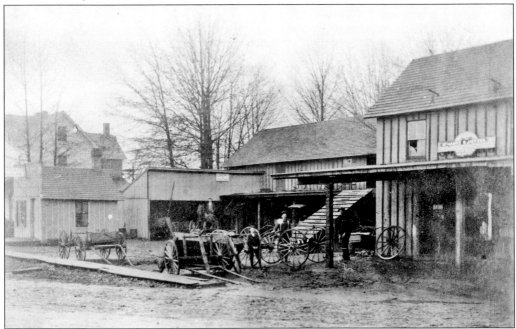

Allie McNamee and Howard Jackson owned this *c.* 1900 blacksmith shop, wheelwright shop, and livery stable at Perryville. At the blacksmith shop was the constant hammering of heated iron to repair farm implements, shoe horses, and replace iron bands for wagon wheels. The wheelwright repaired wooden buggies and wagons. The livery stable rented different sized buggies to traveling salesmen and wagons to local residents working on projects.

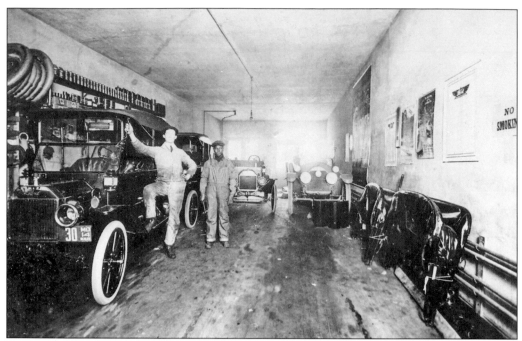

In Elkton, Warren W. Boulden Sr. was the county's first Ford dealer, starting on Main Street and then building this North Street garage in 1915. In this photograph, Boulden stands proudly with his foot on the running board, his mechanic Archie Bryant beside him. The building also had a sales room and a parts department. The first eight Model Ts arrived by train and were sold within a week.

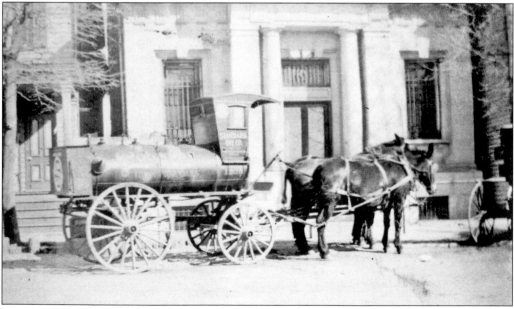

Mass-produced automobiles affected not just how people made a living but how they lived, and not unusual for technological and cultural change, the rate of change was uneven. How else would one explain two mules pulling a Standard Oil tank labeled "for motor cars" in this scene on Port Deposit's Main Street at the dawn of the 20th century?

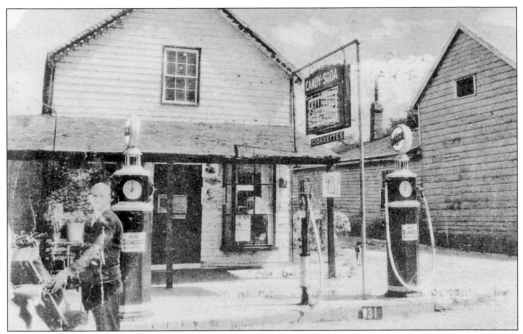

Change occasionally repeats the past. Grocery stores with gas pumps, like Sal Harvey's store in this Depression-era photograph, were common before the transition to service stations, which were common for several decades before the change to convenience stores with gas pumps. Sal Harvey's Service Station was located on Main Street where the parking lot between the North East Post Office and the North East United Methodist Church is now.

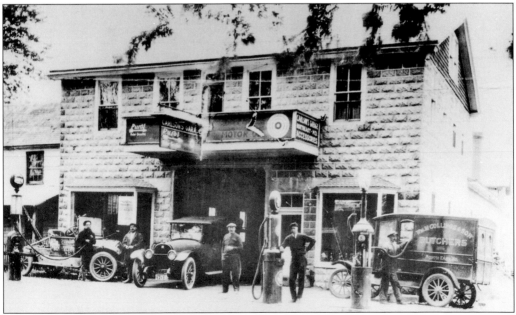

In 1923, Carlson's Garage would provide servicing and vehicle repair for local North East area residents and for motorists traveling along U.S. Route 40 before its realignment. In 1921, Allen Carlson converted the building from a blacksmith shop into a garage. After traffic decreased when U.S. Route 40 was realigned, the business adapted, becoming a car and truck dealership.

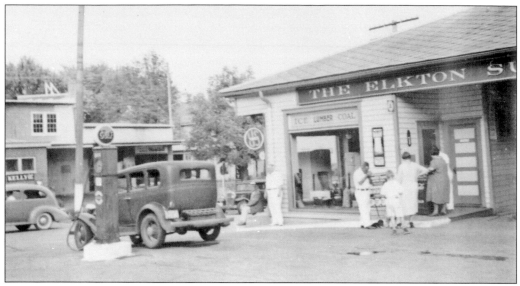

Elkton Supply at Bridge and Main Streets in Elkton expanded their hardware and building supply business to sell gasoline. At the time of this picture in the late 1930s, a major shift in traffic was about to take place. The rerouting of U.S. 40 in 1941 would reduce gasoline sales at Elkton Supply, and this part of the business was eventually dropped.

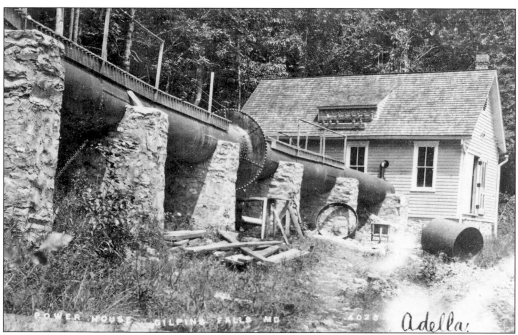

Like the automobile, the production and distribution of electricity ushered in the new century. Electric generating plants, similar to this one at Gilpin Falls around 1905, started on a small scale. The Gilpin Falls plant soon struggled to compete with Home Manufacturing Light and Power Company in Elkton and its boast of providing 24-hour service. By the early 1920s, both companies would be gobbled up by larger power companies.

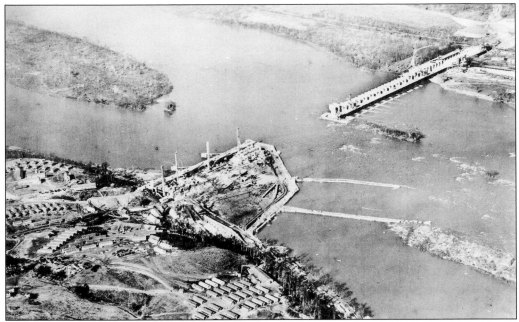

The Conowingo Dam and Hydroelectric Generating Station is shown nearing its 1928 completion as the largest single generating station built in one step at that time. Built by Philadelphia Power, seven turbines produced 252 megawatts of electricity. Later expansion to 11 turbines and other improvements increased output to 548 megawatts. The worker camps at the left in this photograph housed part of the 3,800 workers constructing the dam.

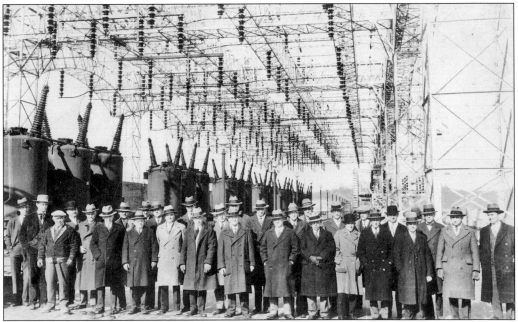

Members of the Elkton Chamber of Commerce visited the Conowingo Dam on February 20, 1929. About 35 members toured the control room, generators, and a tunnel at the bottom of the dam while company representatives explained the generation of electricity. At the time the dam opened, it was the second largest hydroelectric plant in the United States.

Forget about ringing up the operator and requesting a connection to another phone line. Around 1943, these gentlemen oversaw the conversion to an automatic phone system at the three Chesapeake and Potomac switching stations in the county. In 1880, the first line in Elkton ran about 1,500 feet to connect the Scott Fertilizer Company's warehouse with the plant.

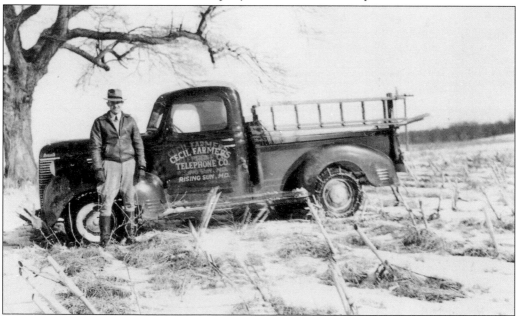

In 1904, the Cecil Farmers Club formed the Cecil Farmers Telephone Company to serve the Rising Sun area; Armstrong Telephone Company replaced that company in 1962. Lineman Ralph Reed is shown here making the rounds to maintain the phone service in the late 1940s. When he was not making his lineman rounds, Reed was running the telephone company as president and owner. (Courtesy of Michael Dixon.)

Four

SERVING

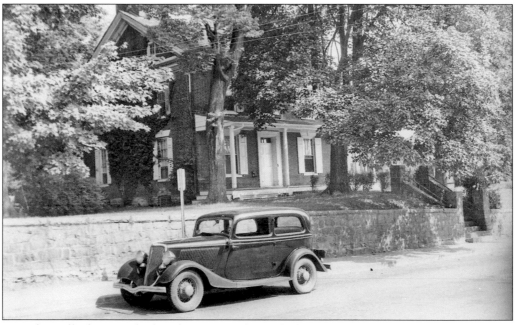

Partridge Hill, photographed in the 1930s and now the home of the American Legion Cecil Post 15, was the home of Col. Henry Hollingsworth, Elkton's best-known Revolutionary War soldier and a prosperous merchant. He served as a quartermaster and commissary, overseeing the flow of supplies arriving from other Eastern Shore areas through Elk Landing and redirecting them to General Washington's army. In his 1780 annual report, Hollingsworth noted sending the following: beef, 5,200,000 pounds; salt beef 48,000, barrels; flour, 40,000 barrels; salt, 4,000 bushels; rum, 17,000 gallons; corn, 56,162 bushels; pork, 5,500 barrels; hay, 200 tons; tobacco, 1,000 hogshead; oats unaccounted. Supplies also moved through Charlestown, and the Brick Meeting House temporarily served as a hospital for Washington's troops. A number of Cecil Countians joined the famed Maryland Line; Col. Nathaniel Ramsey, who stopped a retreat and rallied troops at the Battle of Monmouth, was from Charlestown. In addition to military service, Cecil Countians have served others over the years in a variety of endeavors from the national to the local level.

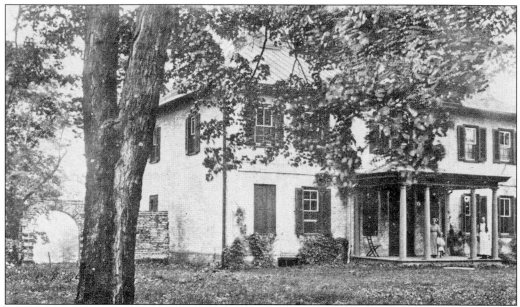

Bohemia, shown here in the 1920s, was the secondary 19th-century home of Louis McLane, a prominent Delaware politician who served in the U.S. House of Representatives and Senate and filled cabinet offices as the U.S. Secretary of the Treasury and Secretary of State. McLane also served as president of the Baltimore and Ohio Railroad. His son Robert, born in Delaware, became a governor of Maryland. (Courtesy of Michael Dixon.)

Fugitive slaves passed through Cecil County, traveling along rivers and hiding on boats going through the canal. Howard's Chapel, a black church built around 1853 and located on Center Street in Port Deposit, is believed to have served as a station along the Underground Railroad for runaways making their way along the Susquehanna. Some fugitives received local help, but giving assistance was dangerous and secretive; consequently the history is fragmented.

Supreme Court justice David Davis of Illinois, an early political advisor and financial supporter of Lincoln, was born near Warwick. (In contrast, Lincoln in the 1860 election did not receive one vote in Warwick or the rest of the First District.) Davis served as associate justice on the Supreme Court, 1862–1877, and resigned from the court to serve as U.S. senator from Illinois, 1877–1883. (Courtesy of Library of Congress.)

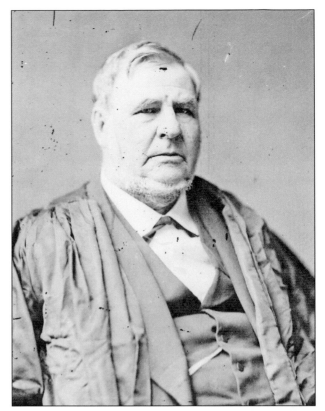

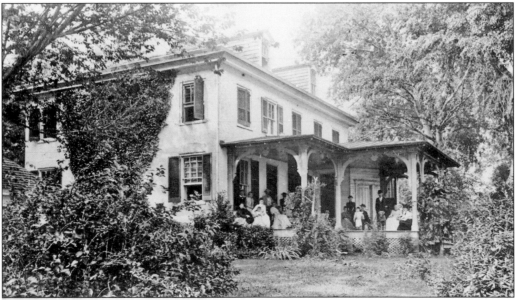

Living in a slave state when the Civil War broke out, many Cecil County residents were torn between Southern sympathy and Union loyalty. At Perry Point, the pro-Southern Stump family was displeased when the Union army requisitioned their farm for a mule school and training ground for teamsters. This family photograph at their Perry Point home was taken in 1893. The Stumps sold the land to the federal government in 1918.

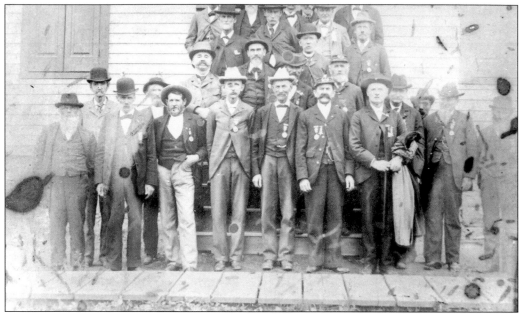

Despite conflicted feelings, most residents who enlisted joined the Union army and served in the Army of the Potomac, like these survivors of Snow's Battery in Perryville in 1900. Alonzo Snow's Battery B, 1st Maryland Light Artillery, was composed mostly of enlistees from the Port Deposit area, and they fought with distinction. A few Cecil Countians joined the South, including the highest ranking officer from Cecil County, Gen. William Mackall.

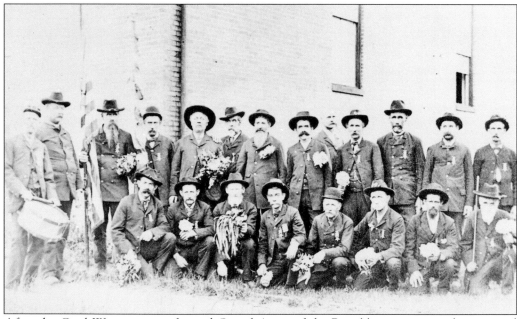

After the Civil War, veterans formed Grand Army of the Republic posts, providing mutual support and keeping memories of the sacrifice alive through Decoration Day activities at veterans' grave sites. Posing in this photograph are members of the North East Wingate GAR Post No. 9 around 1900. In addition to North East, Rising Sun–Calvert, Port Deposit, and Elkton–Cherry Hill sponsored posts. African American veterans also organized a post.

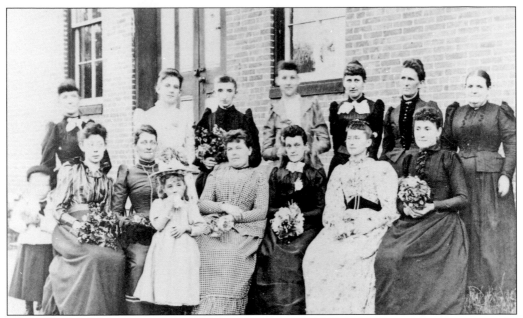

The ladies auxiliary, GAR Wingate Post No. 9, around 1900, holds flowers in preparation for decorating the graves of Civil War veterans on Decoration Day. The women, from left to right, are (first row) May West, ? Laird, unidentified, Lena Foster, Ida Rudy Clark, and Julie Lum; (second row) A. Wildsmith, unidentified, Mrs. Sam Reeder, Carrie Meekins (Simmons), unidentified, Annie Cameron, and Mrs. Jacob Campbell.

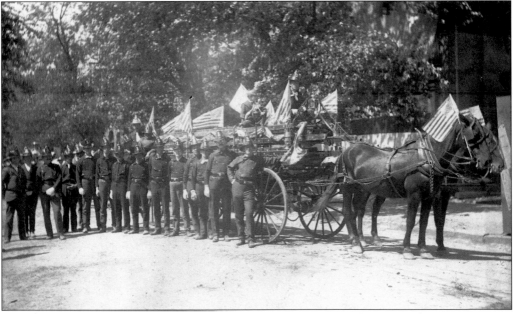

In 1868, the Grand Army of the Republic commander proclaimed a national Decoration Day for annually decorating graves of Civil War dead with flowers. One newspaper reporting on the Decoration Day parade at Elkton in 1902 used the new name, Memorial Day, a day to remember all who while serving died in the nation's wars. The Singerly Fire Company members, standing beside their fire wagon, participated in the 1902 parade.

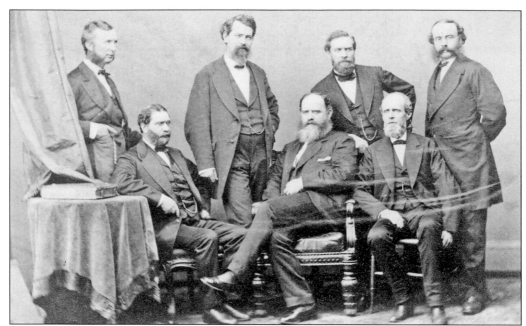

During the war, John A. J. Creswell was responsible for recruiting Maryland volunteers to fill Union military quotas. President Grant appointed Creswell postmaster general. During Creswell's administration, 1869–1874, the first pre-stamped postcards were issued by the U.S. Postal Service. In this photograph, Postmaster General Creswell is seated in the center and surrounded by his assistants. Creswell had also served in the U.S. House of Representatives and the U.S. Senate.

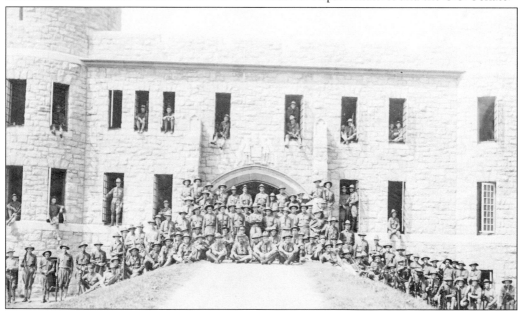

The Elkton Armory was constructed in 1915 to house the local Maryland National Guard unit. The unit was mobilized in 1916 for the pursuit of Pancho Villa. During World War I, the unit guarded Susquehanna bridges and then reported to Anniston, Alabama, for training in preparation for overseas duty. Some units in transit through Elkton for overseas duty boarded overnight at the armory.

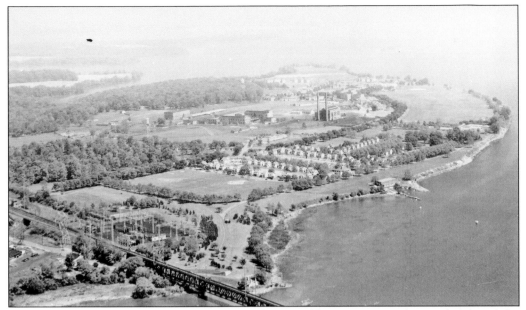

The federal government acquired Perry Point for a World War I nitrate plant and retained the property for a U.S. Public Health Service hospital complex. In 1921, the hospital was turned over to the Veterans Bureau (now the U.S. Department of Veterans Affairs). This picture was taken before World War II and shows the hospital complex and housing. A 44-acre Perryville town park is adjacent to the hospital grounds.

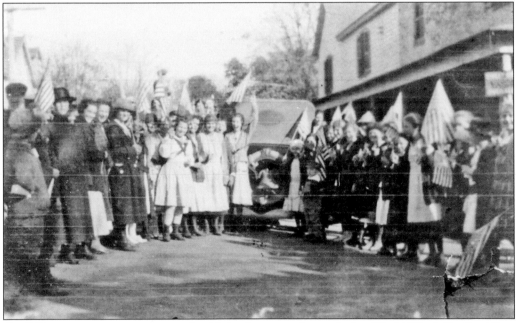

Cecil County newspapers expressed pride in the county's part during World War I; Cecil soldiers were fighting in France, and citizens at home exceeded the Liberty Loan drive quota. News that an armistice was signed brought crowds into the streets. This gathering is at the four corners in Cecilton. The Cecilton crowd celebrated with guns firing, horns blowing, bells ringing, flags waving, and citizens singing patriotic songs.

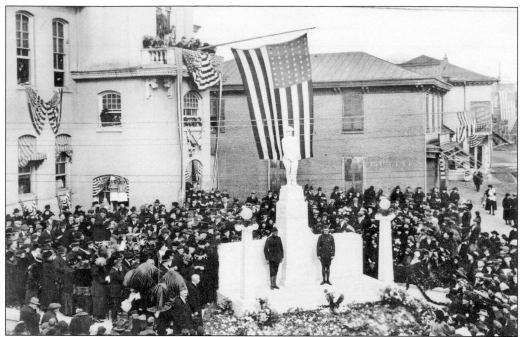

On November 11, 1921, county residents gathered at the courthouse for an Armistice Day parade and to dedicate a Doughboy monument to honor Cecil County's World War I soldiers. Robert Thackery and his wife, Elizabeth, started a fund drive for the monument, collecting a little over $10,000. When the new courthouse was built in 1940, the monument was moved to its present location at the armory entrance.

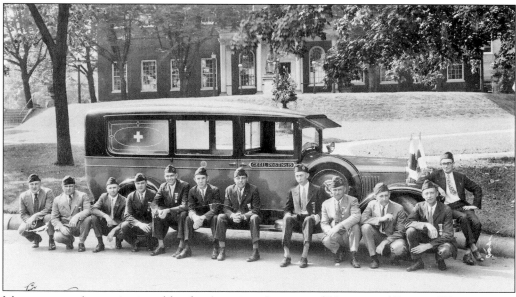

Many veterans' organizations like the American Legion and Veterans of Foreign Wars continue serving the community. In April 1926, the American Legion Cecil Post No. 15 in Elkton provided the county with its first ambulance service. The legionnaires were in Annapolis when this picture was taken; the state house is visible in the background. A local newspaper reported that the service made its 1,000th trip in January 1930.

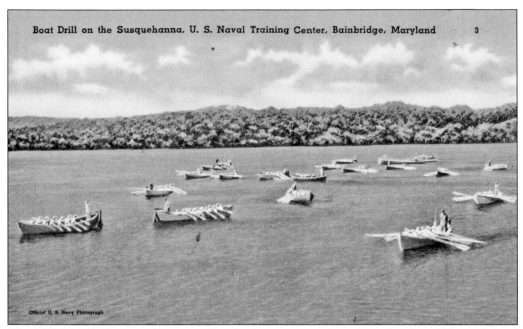

Official U. S. Navy Photograph

The U.S. Naval Training Center at Bainbridge was constructed on the former Tome School campus soon after the Pearl Harbor attack. In 1945, the base had 38,000 personnel, but the number dropped sharply after the war ended. The Korean War brought another burst of activity. Afterward schools and special commands kept the base open until 1976. The local economy followed the same boom and bust pattern as the base.

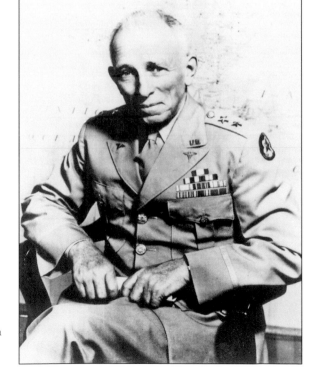

U.S. Army surgeon-general Norman T. Kirk, pictured here, was one of three generals from Cecil County who served during World War II. Gen. James Crothers was a district commander in England, involved in logistics planning for the invasion of Normandy and commander of ports in Cherbourg, France, and Bremen, Germany. Marine Corps general Julian Smith directed the American victory at Tarawa. (Courtesy of U.S. Army.)

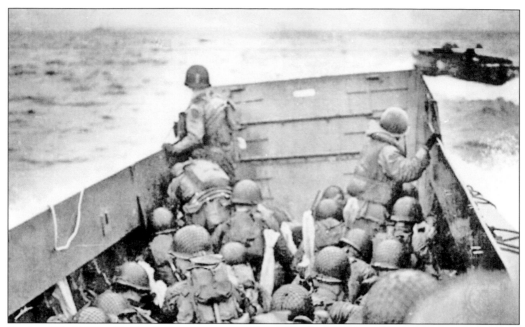

During World War II, Cecil Countians served in every military branch and also made civilian contributions to the war effort, but it was Company E, 29th Division, Second Battalion, 115th Regiment, that would earn their share of the headlines on June 6, 1944. On D-Day, Allied forces stormed the beaches at Normandy. Company E landed with the assault wave securing Omaha Beach amid the carnage. (Courtesy of U.S. Army.)

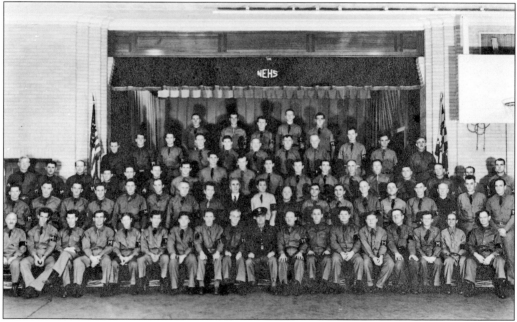

During World War II, the home guard Minute Men backed up the state militia. This photograph was taken in the auditorium at North East High School, now the middle school. The mission was serious, but one local resident recalls one incident in which they were called out to investigate a parachute sighting in Perryville. An enemy agent was not found, but a pop-up toy parachute was.

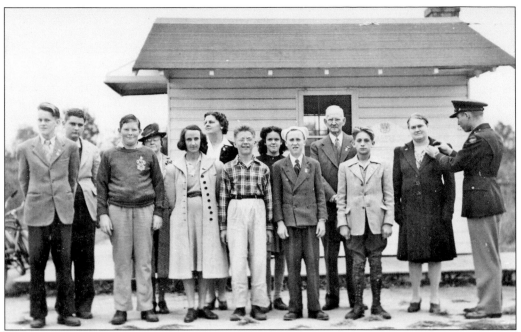

These World War II plane spotters at their post in North East, near the present middle school, are receiving award pins from the Army Air Corps. From left to right are (first row) Stewart Demond, James Millar, Ella Leverage, Otis Sapp, Eugene Meekins, Gifford Biles, Mable Demond, and Lt. H. Blood; (second row) Bo Matthews, Lulu Gibson, Deborah Johnson, Janice Demond, and George Hamilton.

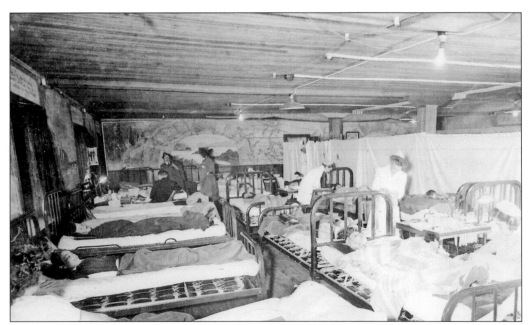

During World War II, American Red Cross volunteer nurses prepared for various medical emergencies by training and practicing their skills in the basement of the Immaculate Conception Catholic Church in Elkton. A mix of volunteer patients and life-size dummies were used in these exercises.

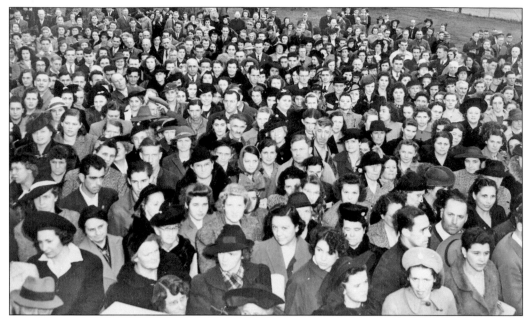

Triumph workers in Elkton in the 1940s, many recruited from other states, manufactured military munitions. These men and women, some of whom are pictured here, served on the home front, but they were not out of harm's way. Several explosions occurred; the most serious one in 1943 took 15 lives and injured around 75 workers. The plant employed approximately 10,000 people, more than the population of Elkton, putting a strain on housing and other services.

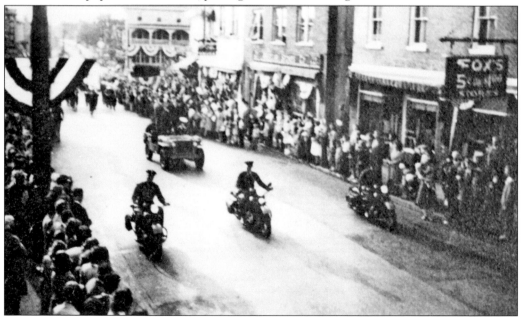

Crowds lined Main Street in Elkton to celebrate the end of World War II and to honor the men and women who served in the military. Units and bands from Bainbridge, Aberdeen, and Edgewood and veterans who had returned home participated in the November 1945 parade. After the parade, Maj. Gen. Norman Kirk, surgeon-general of the U.S. Army and a native of Rising Sun, was the guest speaker.

Cecil County sent its share of native-born politicians to the state house to serve as governor. The Delaware Statehouse is pictured here because the number of Delaware governors from Cecil County (George Read, who also signed the Declaration of Independence for Delaware, Joshua Clayton, Richard Bassett, and Benjamin Biggs) outnumbers the Maryland governors from the county (Thomas Veasey, James Groome, and Austin Crothers). (Courtesy Library of Congress.)

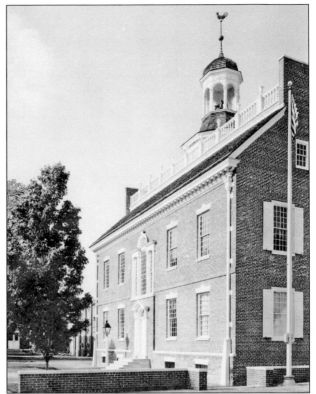

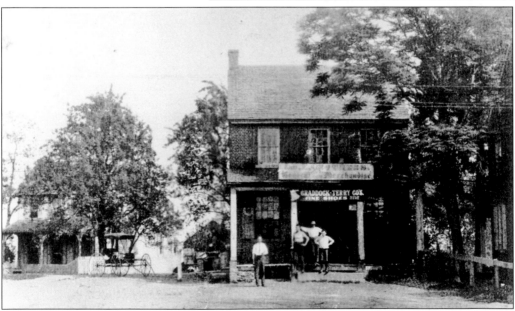

In the Colonial period, three post offices operated in Cecil County, at Charlestown, Head of Elk (Elkton), and Warwick. In the 19th and early 20th century, many villages had a post office, usually situated in a place of business. In Calvert, from 1880 to 1908, the postmaster was James Crothers, who operated the Calvert Post Office from his general store. Calvert lost its post office designation in 1908.

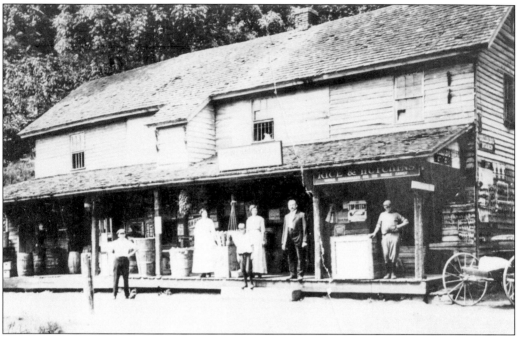

The Rowlandsville Post Office served a mill-town community at Octoraro Creek and operated from 1826 to 1943. This post office and general store, in this c. 1890 photograph, had the convenience of the Octoraro Branch line in front of the store, just out of range in this image. (Courtesy of Michael Dixon.)

Childs gained a post office in 1887, shortly after the village acquired a station on the Baltimore and Ohio Railroad and a new name. Formerly known as Spring Hill, Childs was named for George Childs, owner of the nearby Marley Paper Mill and publisher of the *Philadelphia Ledger*. In this Childs Post Office picture, around 1913, postmaster Daniel Henry McCauley is on the right.

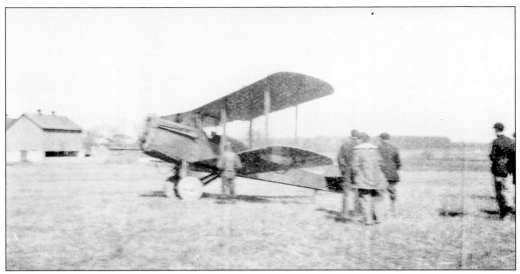

Two notable changes in postal service in the county occurred in the early 20th century. Rural Free Delivery was phased in and was the reason why many village post offices became unnecessary and were discontinued. The airplane brought the other change. This plane landing at Singerly in 1922 was providing airmail service.

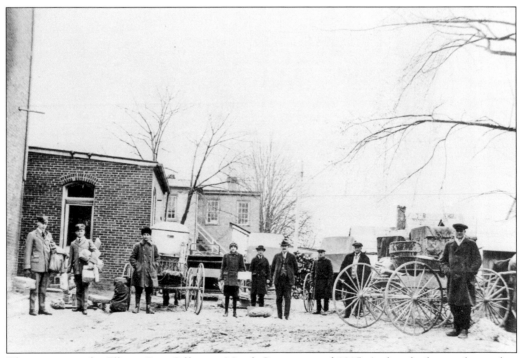

This picture is the Elkton Post Office on North Street around 1915. A close look reveals another change about to take place for postal delivery. Farther back between the two buggies on the left is an automobile (barely noticeable among the buggies except for the steering wheel and windshield). In 1921, residents were instructed to affix house numbers to prepare for town delivery.

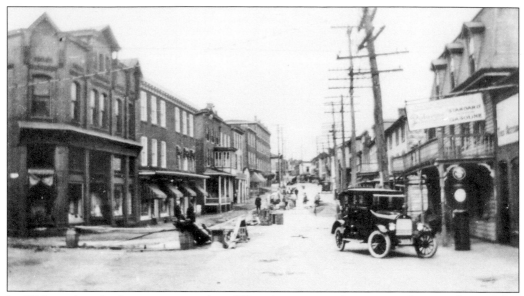

In 1916, workers laid storm sewers along Elkton's streets to drain water from roadways. This scene is Main Street at Bow Street. The drains emptied into Elk Creek, and one local resident complained that the sewers caused a decrease in the previously abundant sunfish population in Elk Creek near Vinsinger's Mill.

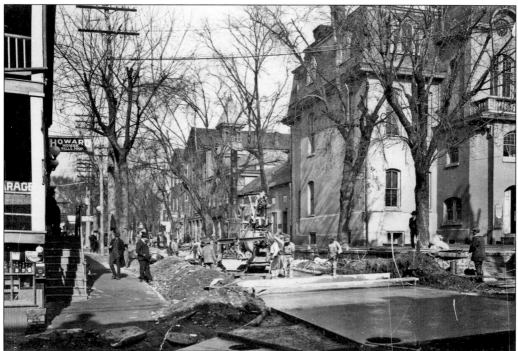

Road networks were improved to meet demands for better roads. In this 1920 photograph, the state was resurfacing North Street in Elkton. The state used convict labor, the trusties housed in the jail. Following this work, the state paved a new concrete surface on Main Street, just prior to the federal government creating a national highway system and designating the street as a part of U.S. 40 in 1926.

Before the automobile, hauling the town drunk and other offenders to the jail in Elkton late at night was impractical. North East built a jail around 1886 to detain prisoners until a justice of the peace was available, or the time was more convenient for a trip to Elkton, or the offender became sober enough to reason with. The building also functioned as a town hall and library.

The last hanging at the Elkton jail was in 1905. John Simpers was executed for the robbery and murder of Judge Albert Constable on Red Hill Road. Detectives from Baltimore solved the case after discovering the victim's watch in a Philadelphia pawn shop. The Maryland Legislature decided about a decade later that all executions should be conducted by the state at the Maryland Penitentiary.

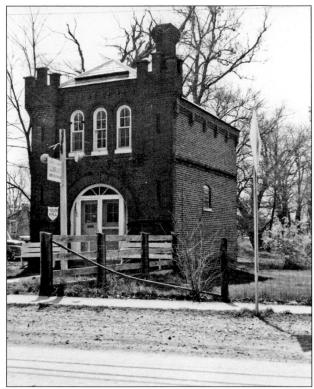

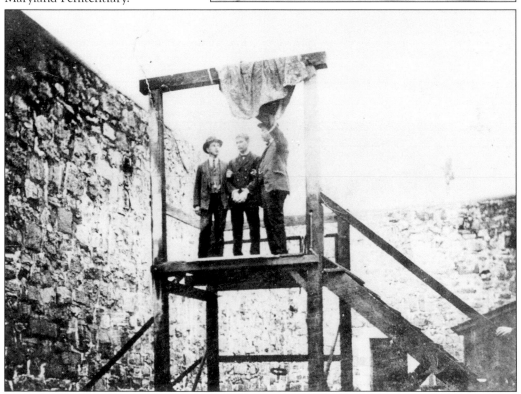

This distant view of the insane asylum near Childs was taken after a snowstorm in 1888 or 1889. The asylum was on the same farm as the county almshouse. In 1902, the asylum had 30 patients, called inmates, and the almshouse housed 34 paupers. After the state took responsibility for the mentally ill, the asylum was closed in 1917 and torn down in 1935.

Chief George Potts, Elkton's first police chief, stands beside a 1929 police car, the town's first. Mayor Taylor McKenney is on the left, and the officer in the car is Albert Buckworth. In 1935, after Potts retired, the Elkton police sparked an international incident Iranians called the "Elkton Outrage." When an Iranian diplomat's chauffer was pulled over for speeding, an argument ensued, and the diplomat was handcuffed; his quick release was not quick enough.

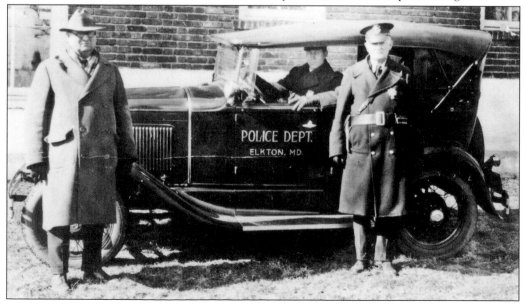

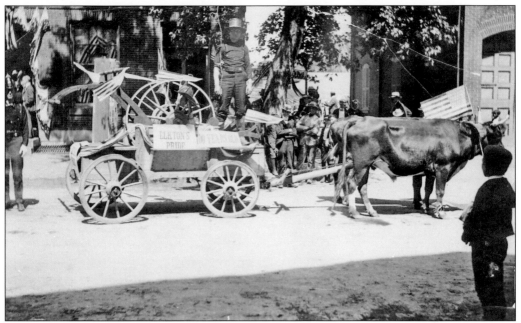

Elkton's Singerly Fire Company, named for William M. Singerly, organized in 1892. In the 1902 Decoration Day parade, the fire company displayed its fire equipment, including a 100-year-old hose cart. The driver with top hat and whip and the ox were intended to create an 1802 appearance. The firefighters may have also exhibited the town's first hand-pumper, a Hyraulion, made in Philadelphia in 1829 (and still in existence).

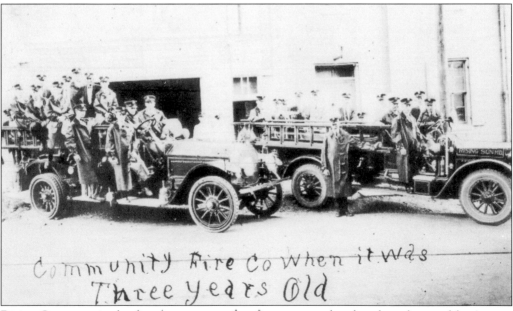

Community Fire Co When it was Three years Old

Rising Sun organized a fire department after fire consumed a church and several businesses in town in 1921. The American La France fire engine cost $10,000. Dr. R. C. Dodson was the Community Fire Company's first president, and John Donache was the first fire chief. Cecil County towns formed volunteer fire companies in the first half of the 20th century. (Courtesy of Michael Dixon.)

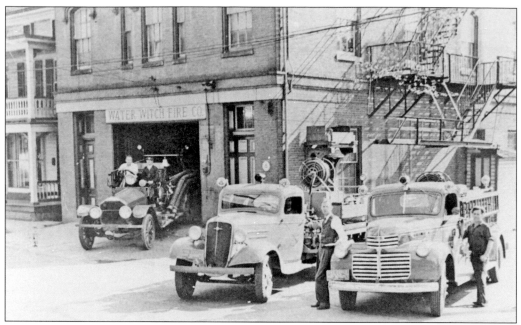

This was Port Deposit's Water Witch Fire Company in the 1940s, when it was located at the Abrahams Building at 14 North Main Street. The second floor was remodeled by the fire company for a social hall. The fire company started in 1844 and was known mostly as the Goodwill Fire Company until it officially became the Water Witch Fire Company in 1883.

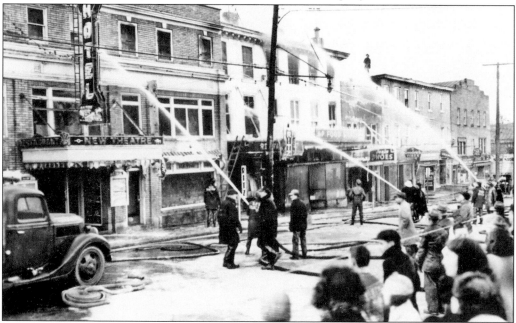

Elkton's Singerly Fire Company responded to a Main Street business district fire in December 1947. The fire brought an end to the New Central Hotel, the town's movie theater located in the building, and several other businesses. The fire company was located just around the corner on North Street, in the Town Council Building. The fire company moved to a new building in 1950. (Courtesy of Maryland Archives/*Baltimore News-American*.)

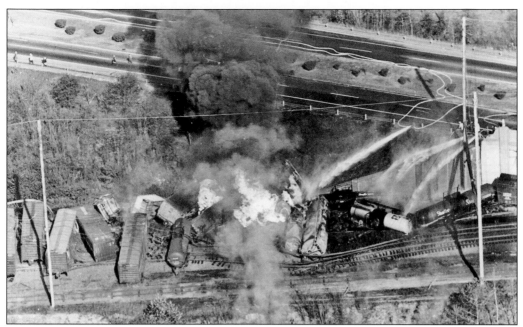

After this Pennsylvania Railroad 41 car derailment outside of Elkton in October 1965, fire companies and supporting agencies from the surrounding area joined forces to battle the resulting fire. The men and hoses are positioned along U.S. Route 40, focusing efforts on the burning tanker cars filled with liquid petroleum gas and other flammable chemicals. Approximately 400 residents were evacuated from their homes. No one was injured in the derailment.

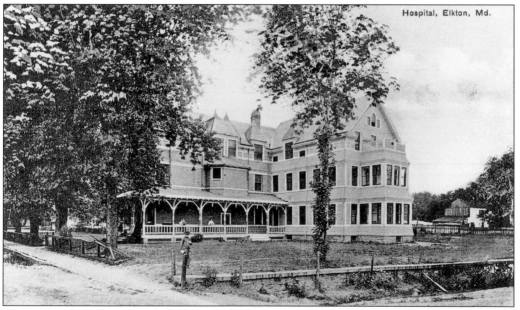

Union Hospital, the county's first hospital, opened to receive patients in December 1908 in a residence originally owned by William Singerly for his extended stays in Elkton when he was away from his publishing business in Philadelphia. The building was located at Cathedral Street and Singerly Avenue. The influx of defense workers during World War II resulted in the hospital expanding into new facilities.

To increase the number of trained nurses, Union Hospital started a nurses' training school in 1911 that continued until 1929. The nurse seated at the center is Mabel Lazelere Lynch. Based on the visual clues, Lynch is apparently the training supervisor, and the three unidentified nurses standing around her are holding graduation certificates.

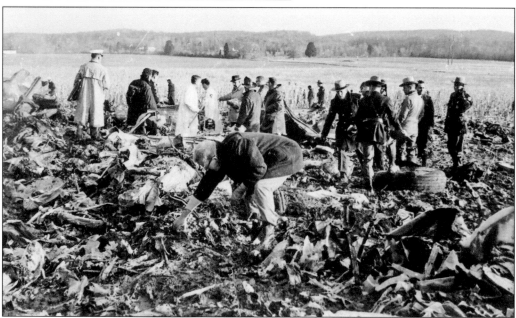

Emergency responders face tragedy routinely, but none are as daunting as the tragedy they faced on December 8, 1963, on Delancy Road. At 8:58 p.m., lightning shattered Pan Am Flight No. 214 over Elkton, with 81 lives lost. Emergency workers combed through the wreckage and collected remains. Aviation engineers studied the disaster to design safer aircraft during lightning storms. In May 1947, an airplane crashed near Port Deposit, taking 54 lives.

In 1916, a group of reformers began what would become the Brookings Institute, the first nonprofit organization established to conduct independent research and make public policy recommendations at the national level. Robert Brookings, one of the group's financial backers, expanded the group's work into two additional areas. In 1927, the three groups merged and were named for Brookings, who was born in Cecil County. (Courtesy of Library of Congress.)

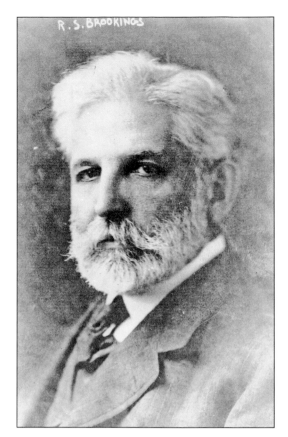

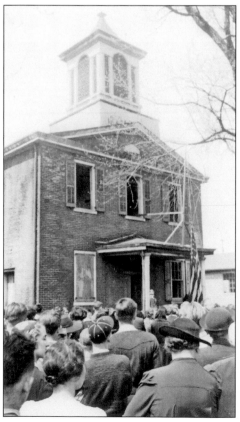

Private schools like the Elkton Academy existed before a public school system. The original building burned in February 1854 and was rebuilt and reopened by November, at the cost of $3,400. Teaching resumed for 35 boys and 28 girls enrolled at the school. In the photograph, a crowd gathers in 1932 to watch the building's destruction after the school had closed around a decade earlier.

Even with a public school system, private schools provide an alternative. The Friends Select School at Calvert, shown here in either 1886 or 1887, served a Quaker population. Mary Ella Griffith is seated at the left window. At the right window are Mary Martindale on the left and Flora Mason. In the back row, Florence Dance is far right and Arrie Nowland is second from right.

The county created a public school system in the 1860s. In 1958, local historian Ernest Howard published a book on the school system's history with details about individual schoolhouses. In this picture showing the teacher and students at Leeds School in April 1895, Ernest Howard is the boy on the right in the back row.

This is Perryville Elementary School on Cherry Street, around 1910, after the second story was added to accommodate more students. Students wishing to attend high school were expected to travel to the Cecil County High School in Elkton. It was not until 1929 that Perryville High School was built on Aiken Avenue.

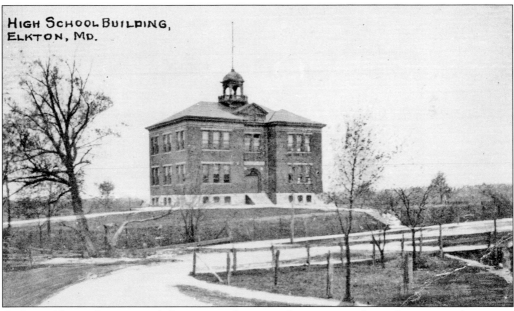

At first, older students around the county who wanted to continue their education might receive some accommodation at their elementary school. In 1896, the same year as this postcard, the Cecil County High School was built in Elkton and open to all students in the county. In 1902, five teachers, including one for manual training, provided instruction. The building was abandoned in 1942 and burned down in 1945.

Distance made attending Cecil County High School difficult for many. Early in the 20th century, more county high schools were built. This is North East High School's first graduating class in 1901. From left to right are Principal Edwin Fockler, Reba Garey, Mary Thompson, Florence Warner, Reba Hyland, Reba McCracken, Irene Foster, and teacher Ida Cooley. Typically in the early years, considerably more girls than boys attended public high schools.

Annual teachers' institutes were conducted to provide more training for teachers. This c. 1896 photograph of a teachers' institute was taken in Port Deposit. The man with the white beard and "xx" at his feet is Cornelius Abrahams, a school commissioner; to the immediate right with an "x" is George Blake, president of the school board; and next to him with the star at his feet is George Biddle, the county superintendent of schools.

Extracurricular activities were added to school programs to broaden student talents and interests. The uniformed school band at Elkton Elementary in 1954, shown in this photograph from that year, along with a band from Gilpin Manor Elementary, participated in the annual School Safety Patrol Parade in Washington, D.C., held in May. The band won the parade's national first prize in 1952 and 1953.

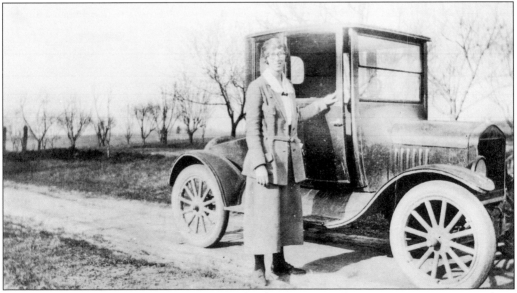

In 1914, the legislature established the Maryland Cooperative Extension Service in agriculture and home economics, under the auspices of the Maryland Agricultural College at College Park. In the 1920s, home demonstration agent Elizabeth Hodgson made the rounds of county farms and villages, showing homemakers the latest techniques for preserving food, sharing information on food safety and preparation, and teaching other modern homemaking ideas.

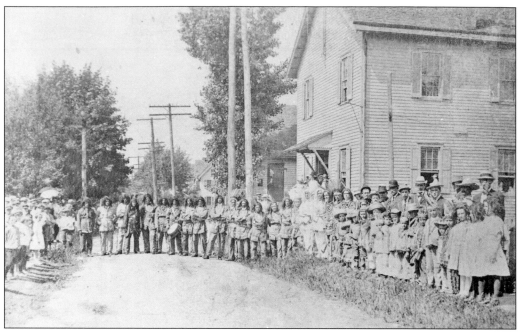

Fraternal organizations and their female counterparts were at their height of popularity after the Civil War and into the 1910s. The rituals, ceremonies, and celebrations suggested their social aspects, but many of these groups, similar to current-day volunteer service organizations, also served their communities. Every sizable town in the county seemed to have its American Mechanics, Odd Fellows (and Rebekas), and Masons, and at least one hall named for a fraternal group, halls that were often used for public events. The Red Men organization was one of these groups, like these bedecked "warriors" and their younger versions standing at the Perryville Mechanics Hall around 1900 in the above picture. Pocahontases, like these from the Shawnah Council in North East in 1932, pictured below, were the auxiliary to the Red Men.

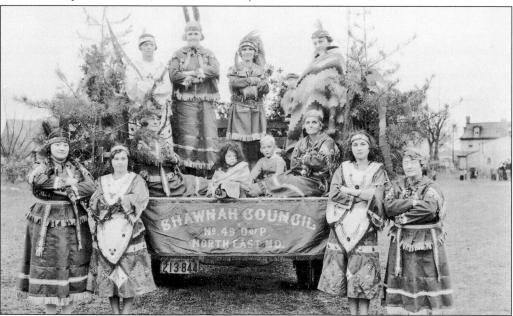

Five

ENJOYING, RELAXING, AND REFLECTING

Up to the 1920s, Mechanics Hall (on the left) and the Opera House were the civic, cultural, and entertainment centers for the county. Starting in 1867, town residents attended plays, lectures, public meetings, and music recitals on the second floor of the International Order of Odd Fellows Hall, which around 1900 was remodeled as the Opera House, a popular name towns liked to use to sound more cultured. In 1908, the Opera House began advertising regular showings of moving pictures. Mechanics Hall, built early in the 20th century, offered similar activities and occasionally served as a drill hall for the local Maryland National Guard unit before the armory was built in 1915. Every town that was large enough for fraternal organizations like Masons, Odd Fellows, Grand Army of the Republic, Mechanics, Red Men, Sons of Temperance, or a fire department often had at least one hall bearing an organization's name that was used as a center for social, community, and fund-raising activities. Some halls even doubled as or became town halls.

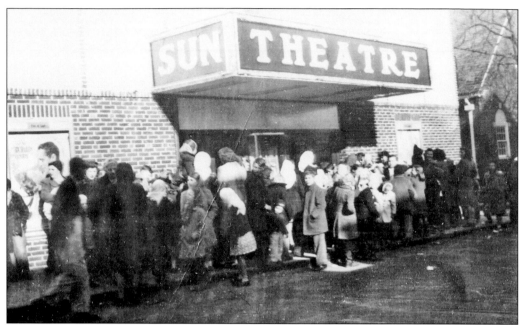

Movie making improved and movies gained popularity, causing a change from makeshift movie houses to theaters designed for larger audiences in towns throughout the county. A crowd gathers at the Sun Theatre in Rising Sun around 1948 in this photograph. Competition from television and larger theaters ended small-town movie theaters in the county by the late 1960s, except Elkton's last theater, which closed in the 1980s. (Courtesy of RSHPC.)

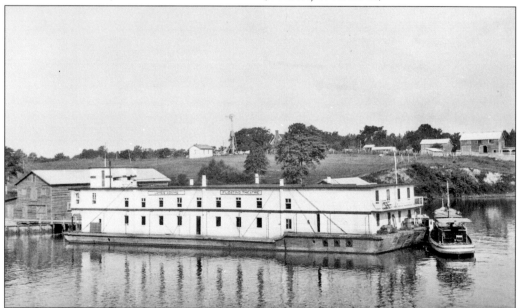

Appearing at ports from North Carolina to Maryland, the James Adams Floating Theatre provided live performances from 1914 to 1941, with Port Deposit, North East, Elkton, Chesapeake City, Charlestown, and Georgetown (across the river from Fredericktown) on the itinerary. Edna Ferber's research for *Show Boat* was on the Adams Floating Theatre, a barge pulled by tugs. When James Adams and his wife, Gertrude, retired, they moved to Chesapeake City.

The Cecil County Agricultural Society started holding county fairs in 1880, north of Railroad Avenue between Bridge and North Streets on 28 acres enclosed by a fence. Prizes were awarded for livestock and domestic product categories and visitors could see the latest in farm machinery. Mitchell Hall, shown in this *c.* 1895 view, was added in 1884. Financial problems ended the fair before the 20th century started.

Crowds gathered in the grandstands to watch running and trotting races on the oval track at the Elkton fairground. In the first year, the race premium was set at $1,675. Owners raced their horses in trials of speed and in harness race trials for a combination of speed, strength, and endurance. An 1877 atlas shows additional trotting courses, one near Elkton at Blue Ball Road and one in Warwick.

William DuPont Jr. began steeplechase races at his Fair Hill property in 1934. The 5,633-acre property is now the Fair Hill Natural Resources Management Area, owned by the state for public use, and the Fair Hill International races have resumed, as have flat races. The DuPont family promoted horse breeding in the county, and Kelso, Northern Dancer, and Barbaro have galloped over Cecil County fields.

The Maryland State Police and other groups honored "Rodeo" Earl Smith on his 85th birthday in 1979. Rodeo Earl enjoyed a colorful career as a Wild West show performer in the 1890s, a Hollywood stuntman in Westerns, and an amusement park operator near Philadelphia. When he retired to his Silver King Ranch outside Perryville, he retained his Wild West persona for public appearances, advertising himself as "America's frontier two gun deputy sheriff."

As baseball became increasingly popular in the decades after the Civil War, communities throughout the county formed their own teams and competed with other local communities. The Appleton team is pictured here from around 1900, at the corner of Route 273 and Appleton Road. At least two African American teams, one at Port Deposit and one at Cecilton, played in the county.

Standing left to right
Bill Rose
Frank Denney Jr.
Geo Elliot Brown
Fred H. Leffler
Billie Scott
Hamill Denney
Frank Denny Sr
Butts McCable
Frank Brown
Earnest Brickley
Sam H. Boyer
Billy Johnson
Cletus Finnan

In 1866, baseball teams played in Elkton, Rising Sun, West Nottingham, and Chesapeake City, which had two teams. Intra-county and inter-county leagues kept forming, collapsing, reorganizing, and renaming for over 50 years. The owner of this postcard recorded the names of the 1906 Elkton baseball club players.

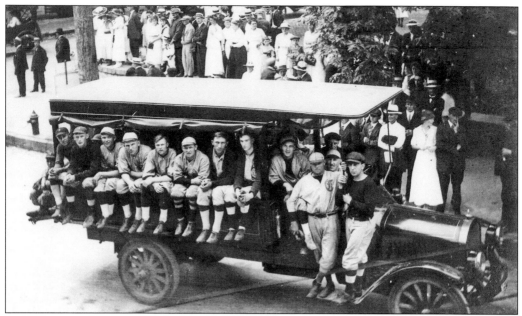

In 1920, around the time this photograph of the Elkton team arriving for an away game was taken, a regional league had stabilized. The Susquehanna League would remain the dominant regional league for four decades. Some fans complained about the Elkton team's change in status from amateur to professional.

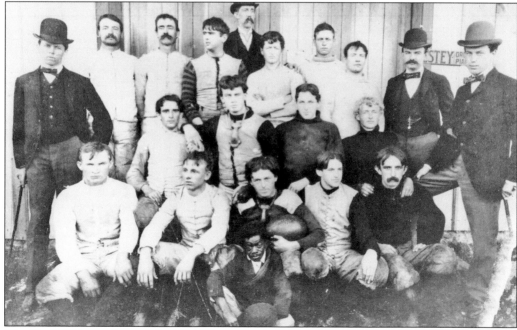

The *Cecil Whig* proclaimed the 1894 Elkton Football Club "the best the town has ever put forth." Home games were played at the Elkton fairgrounds, and the schedule included teams from outside the county. The players in the photograph are unidentified, but the newspaper provided a roster of last names: Carter, A. Ward, Shaffer, Garrett, L. Ward, R. Wilson, H. Constable, J. Wilson, McKenney, J. Constable, and Evans.

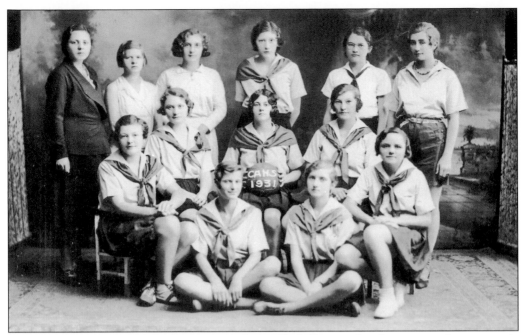

Beginning in 1914, some school sports, including volleyball, were played at an annual county-wide track and field meet, with various competitions played at high school and elementary school levels. In the 1931 track and field meet, the Calvert High School volleyball team defeated Kenmore High School 15-4 but lost to Cecilton High School 13-7.

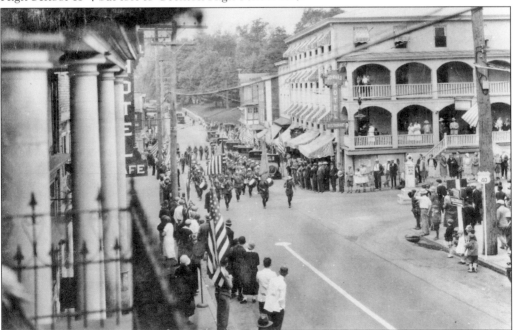

In the 1920s and 1930s, the American Legion Cecil Post No. 15 and Company E of the Maryland National Guard staged Memorial Day and Armistice Day parades in Elkton. Usually in these marches, the Elkton band, the drum and bugle corps from the Cecil Post, the ladies auxiliary of the Cecil Post, and Company E marched down Main Street to the Doughboy monument.

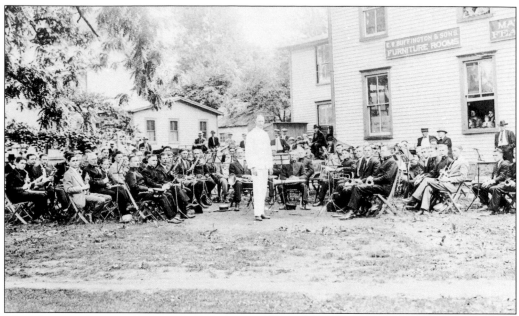

This photograph was taken beside E. F. Buffington and Sons Furniture Store at the southwest corner of Walnut and Main Street in Rising Sun in the 1920s. The occasion was a guest concert hosted by the Rising Sun Fire Company Band, with members of neighboring bands participating. The Rising Sun members are identifiable by their new uniforms. The bandleader was Prof. C. F. Schlosser, a paid leader from Baltimore.

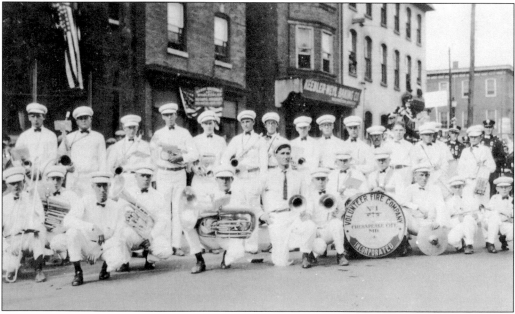

When larger communities celebrated special events, bands from other communities were invited to represent their towns. This image from around 1925, the year the band was organized, shows the Chesapeake City Volunteer Fire Company Band in Wilmington, Delaware, for a performance. Prof. C. F. Schlosser of Baltimore worked with this band as well as several other community bands in the county.

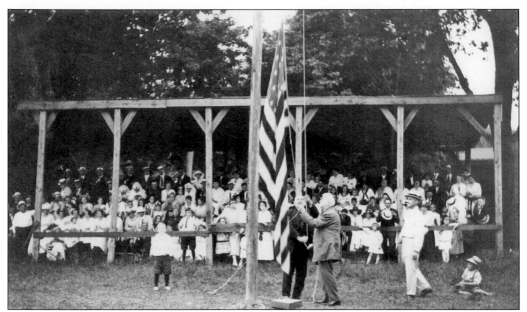

A flag-raising ceremony often preceded a community event in the late 19th and early 20th centuries. Another common flag-raising event in that era was the presentation of a new flag to a school or other public institution. Fraternal and patriotic organizations would donate a new flag to a school during appropriate exercises, including a presentation speech by the donor and a county official or school representative officially accepting the flag.

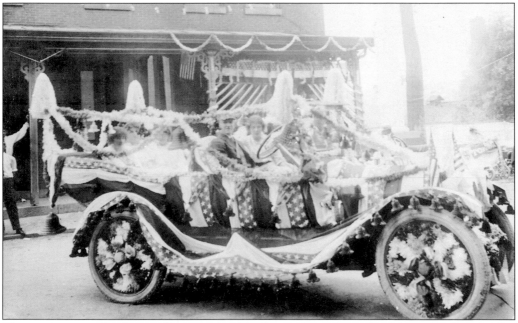

This car's owner displays enthusiasm for Port Deposit's centennial celebration in 1913. The centennial was observed throughout the year and highlighted with a series of events—a parade, dinners, picnics, speeches, and lectures—for a three-day period that started on the Fourth of July. The building in the background was the Colburn apartments, which also housed the post office. Tome School pennants are visible in the background.

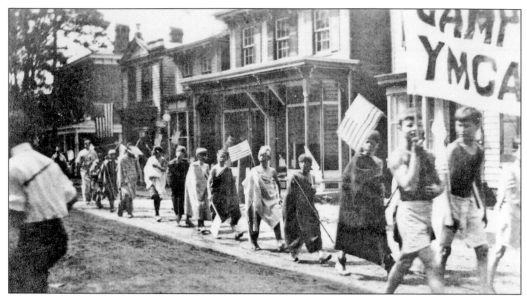

These YMCA campers marching down Main Street in Port Deposit in 1912 participated in the Fourth of July parade with members of other organizations, floats, and automobiles. A baseball game and patriotic activities were held after the parade. A suffragist created a stir by displaying a "vote-for-woman" flag during the celebration. The day ended with a float in the river unleashing a traditional fireworks display.

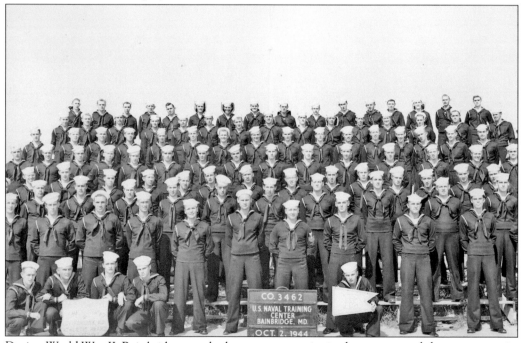

During World War II, Bainbridge was the largest community in the county, and the event recruits most looked forward to was the completion of boot camp. This Company No. 3462 photograph, taken October 2, 1944, marked the occasion, with an added plaque identifying the company as the winner of the athletic achievement award. Four regiments, each housed in four separate areas at the base, trained 5,000 men each.

These readers are checking out a book sale at the Cecil County Public Library at 135 East Main Street in 1970. The library and the Historical Society of Cecil County moved into this building in 1955, and the library moved to a new building on Route 279 in 1988. The former library building is shared by the historical society, the Cecil County Arts Council, and the Cecil County Land Trust.

Extension service home demonstration agents encouraged the creation of homemakers' clubs. Women from these clubs would spend time at College Park to learn and share homemaking skills with others from around the state, benefiting from the educational and social experience. These Cecil County homemakers were photographed while at College Park in 1926.

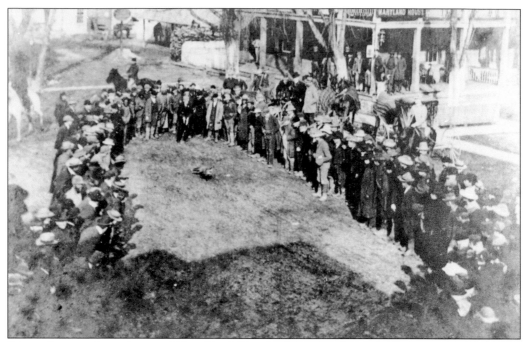

Rising Sun conducted annual New Year's Day fox hunts in the early 20th century. Walter B. Cooney, the event's organizer, is shown releasing the fox in this 1903 photograph taken at Center Square and the Maryland House. Walter Cooney purchased the Maryland House in 1915 after selling his bakery. (Courtesy of RSHPC.)

These hounds and hunters took part in Rising Sun's annual fox hunt. The picture was taken at Spready Oak, and in the picture, from left to right are Lee Cooney, Elizabeth Cooney, David Cooney, unidentified, Walter B. Cooney, unidentified, and Charles McNutt. (Courtesy of RSHPC.)

The automobile widened the range for social and recreational activities. In the driver's seat of this HRH, forerunner of the Hupp Mobile, is E. Kurtz Taylor, who served as Cecil County treasurer in 1909. His brother Robert is in the rear seat, and the children are Kurtz's nephews. The photograph was taken in 1912, fifty-one years too soon for entry at the Cecil County Dragway in Bayview.

These bikers on Elkton's Main Street, around 1898, are riding newly designed bikes, safer than the large wheel–small wheel combination and, thanks to the pneumonic tire, more comfortable than earlier bikes with equal-sized wheels but with hard rubber tires. The bike's popularity was given credit for liberating women from the bustle and corset in favor of more comfortable clothing for biking.

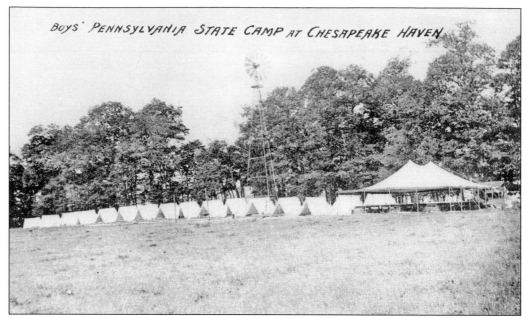

The Boys' Pennsylvania State Camp at Chesapeake Haven is featured on this postcard around 1910. That Pennsylvania, with an abundance of camping areas, would have a camp in Cecil County in the early 1900s testifies to the county's attraction to campers. Chesapeake Haven's location on the Chesapeake Bay at Grove Point provided the added attraction. (Courtesy of Michael Dixon.)

These campers in 1946 were at Happy Valley, a popular camping area outside Port Deposit. Happy Valley Camp was owned by Mr. and Mrs. Fletcher Williams. At least one Boy Scout camporee was held at the site, a three district gathering in 1949. The camp was established in 1933, and by the mid-1950s, it was known as the Happy Valley Riding Camp for Girls.

Major scout camps are located in the county. This flag-raising scene is at Camp Rodney at Elk Neck, around 1970. The Delmarva Boy Scout Council owns Camp Rodney. The Chester County Boy Scout Council maintains Horseshoe Camp near Rising Sun, with an adjoining camp just across the state line. The Chesapeake Bay Girl Scout Council operates a camp at Grove Point, near Earleville, and the Girl Scouts of Central Maryland have two camps at Conowingo.

The Turkey Point Lighthouse, the residence beside it gone since 1971, is part of Elk Neck State Park, with over 2,000 acres used for a variety of outdoor activities. Dr. William Abbott bequeathed his farm to the state in 1936, and the land became the state park's nucleus. The acquisition also became the catalyst for creating Elk Neck State Forest. Civilian Conservation Corps workers prepared the park site in 1937.

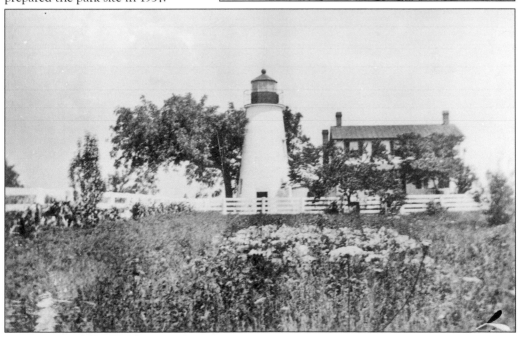

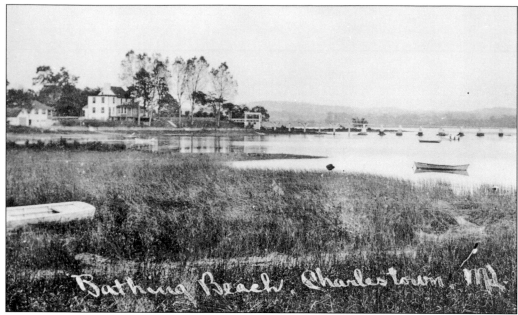

Bathing Beach, Charlestown, MD.

Close to urban areas, Cecil County's waterways and 3,600 acres of marsh in the late 19th and early 20th centuries drew prosperous sportsmen. Hunters joined together, purchased or rented land, and organized gun clubs, such as the Eagle Gun Club in Charlestown, as seen from Burke's Beach above. Wild celery made the Susquehanna Flats attractive for ducks and consequently attractive for duck hunters. Boats at the flats deployed sink boxes and large numbers of decoys. Hunters armed with automatic shotguns, introduced in the United States in 1904, had considerable firepower. Large kills led to increasingly restrictive hunting laws; Congress ended market hunting in 1918, and the federal government outlawed sink boxes and bushwhack rigs in 1935. Local watermen would also take fishing and crabbing parties to the flats. Crabbing parties were also active on the Sassafras.

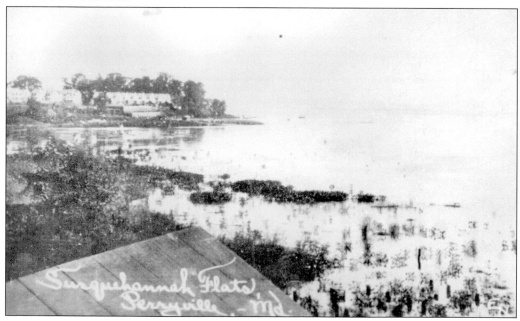

Susquehannah Flats, Perryville, MD.

The 1907 Cecil High School graduating class and chaperones celebrated on the *Spray*. A local newspaper reported that one evening Charles McChesney "gave a delightful sailing party on the yacht." On Decoration Day, Prof. Carroll Edgar took the class and guests to the resort at Betterton on the *Spray*. Principal Frank Evans entertained the class on the *Spray* on another evening. The "Ralph" noted on the card was either Ralph Davis or Ralph Garrett.

Waterside businesses provided gas, goods, and services for boaters, with increasing attention to recreational boaters. Around 1910, Joseph Schaefer opened a store and warehouse on a Chesapeake City wharf for the convenience of boaters. In the 1930s, his children expanded the business, adding a restaurant specializing in crab dishes. This photograph shows the store and original restaurant in 1949. (Courtesy of Michael Dixon.)

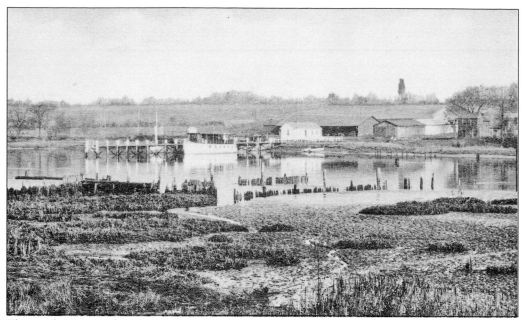

The nearly vacant Chesapeake Yacht Club, around 1910, projects a misleading image. Recreational boaters cruise, sail, and paddle along every county shoreline. Thirty-five marinas on five rivers and the canal and access to the Chesapeake Bay beckon boaters throughout the region. In warm weather, cars stream down Route 272 with boats in tow; North East residents refer to their visitors good-naturedly as "the Pennsylvania Navy." (Courtesy of Michael Dixon.)

Excursion passengers embark on the steamboat *Susquehanna* at Port Deposit in this 1905 photograph. This and other steamboats owned by the Tolchester Beach Improvement Company were used to reach the beaches, picnic grove, and amusements at Tolchester Beach in Kent County. Romantic couples could board the steamboat for a moonlit evening of band music and dancing while the steamboat circled upper bay waters before returning to port.

This 1940 boater's-eye view of Charlestown illustrates the popularity of beaches like Holloway Beach and Charlestown Manor for swimming and boating. Beach cottages sprang up at Charlestown and Carpenters Point. Beaches along the North East River became regionally popular around 1920 and into the 1950s. Holloway Beach advertised heavily, promoting cottage lots and touting attractions like speed boat and airplane rides, a 30-passenger party boat, picnics, games, "crystal clear water" for swimming, a concession stand, dancing, a diving tower, a merry-go-round, and Fourth of July fireworks sales. The Chesapeake Bay Bridge, completed in 1952, and improved highways made the Atlantic Ocean beaches easier to reach for people in the Baltimore area, and many residents in the beach communities no longer sought summer crowds. The photograph below is a Holloway Beach scene from 1939. (Both courtesy of Michael Dixon.)

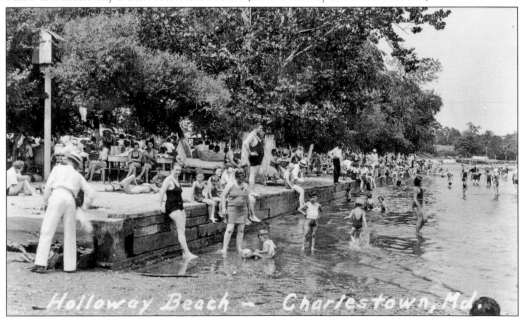

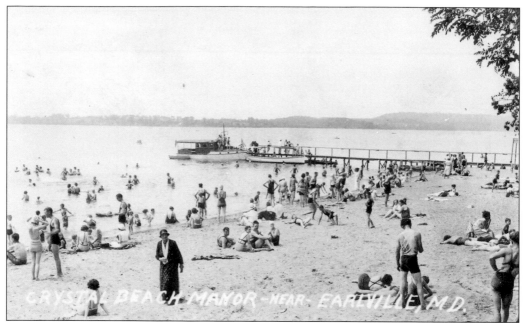

Beach communities also developed along the Elk River and the east side of the bay. Many of Cecil County's beach communities developed in the first half of the 20th century. Developers hoping to rival Tolchester Beach in Kent County laid out Chesapeake Haven on Grove Point by 1908. Crystal Manor Beach, in the above picture from 1934, is one of the better-known beaches in the county. Development at Crystal Beach Manor began in 1925, and the owners were advertising cottage lots as late as 1956. Crystal Beach is still open to the general public. Visitors to Crystal Manor Beach looking for a meal could stop at the Manor Inn. After December 5, 1933, when Prohibition ended, the sign by the door made it clear that beer on tap was also available. (Both courtesy of Michael Dixon.)

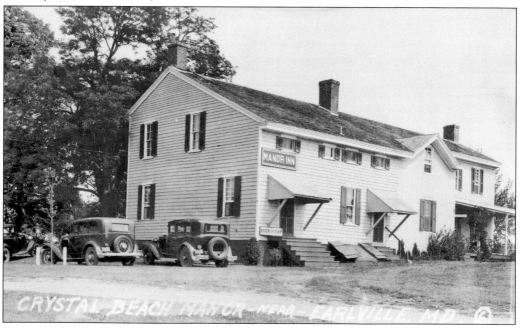

In this 1970 photograph, Susquehanna fishermen appear to be ganging up on the remaining hickory shad after the collapse of commercial fishing in the county in the early 20th century, which was due to overfishing; but the bay, rivers, and freshwater streams still hold plenty of fish, in number and variety, to appeal to the county's recreational anglers.

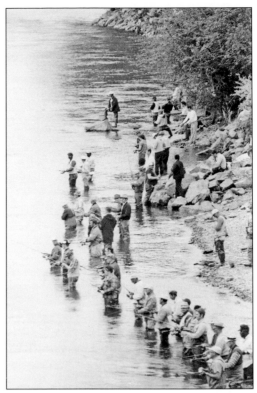

Born in Ohio, Martha Finley, who captured the imagination of children for generations with her Elsie Dinsmore series, was already a successful author when she moved to this house in Elkton in 1876 and continued her writing career. The Elsie series, Finley's best known but not her only work, contained 28 volumes and was written over a span of 38 years.

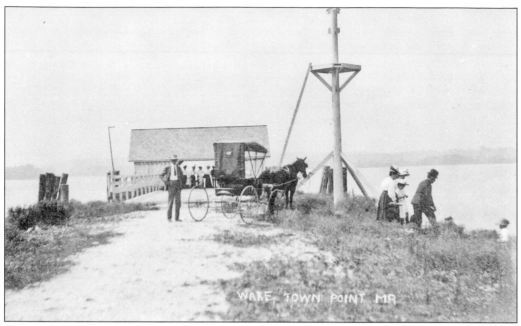

The idea of a leisurely Sunday drive did not originate with the automobile, as suggested by this photograph at Town Point Wharf on the Elk River. The group gathered on the wharf is possibly waiting for a steamboat. Notice the observation platform with the ladder. The old Town Point Wharf was located at the end of Gour Road. (Courtesy of Michael Dixon.)

The Local Preachers' Association conducted an annual camp meeting at Leslie, near North East, from the mid-1890s until 1919; this photograph shows the pulpit or tabernacle from that period. Around 1919, the Copson Park Holiness Association consolidated with the Philadelphia District of the Church of the Nazarene to hold camp meetings at the site. Later cabins replaced the tents and the campground remained active until recently.

The Woodlawn Campmeeting Association started conducting two-week camp meetings in the early 1870s. They purchased a grove of nearly 14 acres and sold tent lots. The grounds included a tabernacle, a boarding tent, and an ice cream and confectionery stand. The top photograph, from around 1895, shows a row of Woodlawn tents with Cornelius S. Abrahams's cottage on the right. Abrahams, secretary of the association, supervised the camp site. The guest preachers, services, and music reinforced the spiritual reason for camp meetings, but the meetings also fostered a sense of community and met social needs. The auto hack, pictured below around 1906, provided a convenient means of transportation to and from the camp. After the camp closed in 1913, several former participants blamed the automobile for the demise of the camp meeting by making other attractions at greater distances more accessible.

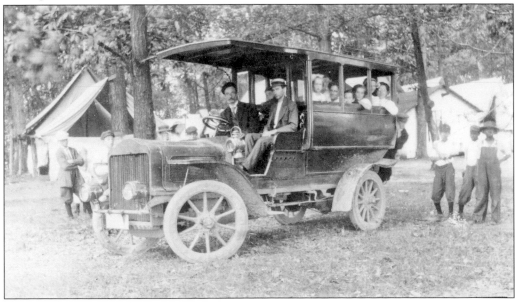

www.arcadiapublishing.com

Discover books about the town where you grew up, the cities where your friends and families live, the town where your parents met, or even that retirement spot you've been dreaming about. Our Web site provides history lovers with exclusive deals, advanced notification about new titles, e-mail alerts of author events, and much more.

MADE IN THE USA

Arcadia Publishing, the leading local history publisher in the United States, is committed to making history accessible and meaningful through publishing books that celebrate and preserve the heritage of America's people and places. Consistent with our mission to preserve history on a local level, this book was printed in South Carolina on American-made paper and manufactured entirely in the United States.

This book carries the accredited Forest Stewardship Council (FSC) label and is printed on 100 percent FSC-certified paper. Products carrying the FSC label are independently certified to assure consumers that they come from forests that are managed to meet the social, economic, and ecological needs of present and future generations.

FSC
Mixed Sources
Product group from well-managed
forests and other controlled sources

Cert no. SW-COC-001530
www.fsc.org
© 1996 Forest Stewardship Council

Find Your Place in History.